# COLOR SECRETS
### FOR
## *Glowing* Oil Paintings

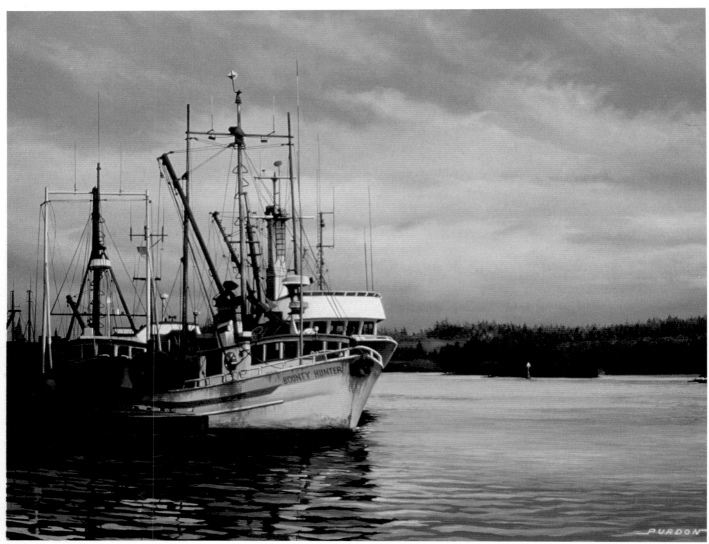

LIFTING FOG
*oil on canvas, 22" × 28" (55.9cm × 71.1cm)*
*Private collection*

# COLOR SECRETS
### FOR
## *Glowing* Oil Paintings

## DOUGLAS PURDON

**NORTH LIGHT BOOKS**
CINCINNATI, OHIO

## About the Author

Douglas Purdon was born and resides in Toronto, Canada. He graduated from the Ontario College of Art and Design in 1987 with a degree in Fine Art. He is a full-time painter who works in oil, acrylic and watercolor, choosing the medium he feels will best suit each subject. Besides painting his native Ontario, Purdon enjoys the challenge of painting in new locations—recent trips have taken him to the Queen Charlotte Islands of British Columbia, Monument Valley, Utah and the western highlands of Scotland.

Purdon enjoys teaching and conducts classes and workshops in both the U.S. and Canada. His paintings are in corporate and private collections in Canada, the United States, Britain and Japan. He is represented by Archive Inc. in Toronto and Cornerstone Gallery in Stirling, Scotland. Purdon is a professional member of The Arts and Letters Club of Toronto and has been elected to the Society of Canadian Artists.

## Acknowledgments

I wish to thank the following people who helped make this book possible: My editor Pamela Seyring, without whose assistance my transformation from artist to writer wouldn't have been possible; Wendell M. Upchurch, educational and technical services manager for Winsor & Newton; Duncan McPhail, Canadian regional manager for Winsor & Newton; Rob Howard, Sysop, Artist's Forum CompuServe; Nita Leland, fellow traveler on the highway of writing and painting; Sue MacLean, who kindly took notes of my lectures so I could use them for reference when I was writing this book; SCL Imaging Group Ltd., who did the color processing for the photography in this book; the owners of the paintings who generously lent them to me for inclusion in this book; and to all my students from whom I have learned so much.

Other fine North Light Books are available from your local bookstore, art supply store or direct from the publisher.

02  01  00  99  98     5  4  3  2  1

**Library of Congress Cataloging-in-Publication Data**

Purdon, Douglas.
   Color secrets for glowing oil paintings / by Douglas Purdon.—1st ed.
     p.  cm.
   Includes index.
   ISBN 0-89134-831-X (hc : alk. paper)
   1. Color in art. 2. Paintings—Technique. I. Title.
ND1488.P87   1998
752—dc21
                                         98-4123
                                         CIP

Edited by Pam Seyring and Jennifer Long
Production edited by Bob Beckstead
Cover and interior designed by Sandy Kent

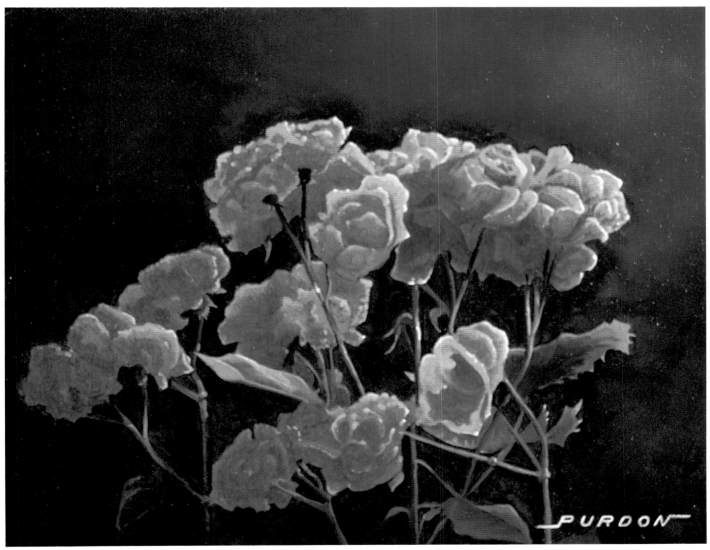

MORNING ROSES
*alkyd on canvas, 8" × 10"  (20.4cm × 25.5cm)*
*Private collection—Canada*

# Table of Contents

Introduction

8

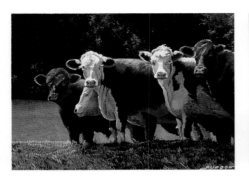
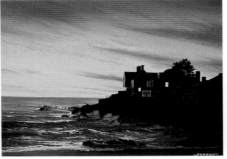

## 1

*Starting Out Right*

10

## 2

*Glowing Colors for Luminous Effects*

20

DEMONSTRATION 1

The Agathlan

26

DEMONSTRATION 2

Waiting for Spring

35

DEMONSTRATION 3

Land of the Mountain
and the Flood

41

DEMONSTRATION 4

Red Rocks of Sedona

48

DEMONSTRATION 5

Bounty Hunter

54

## 3

*The Alkyd Advantage*

62

DEMONSTRATION 6

Old Angus

65

DEMONSTRATION 7

Sheldaig Island Evening

70

# 4

*Building a Painting*

76

DEMONSTRATION 8

October Morning

77

DEMONSTRATION 9

Kew Cottage

83

DEMONSTRATION 10

River Torridon and
Sgurr Dubh

91

DEMONSTRATION 11

Lobster Cove

99

# 5

*Fixing Problem Areas*

110

DEMONSTRATION 12

Carousel Chargers

112

# 6

*Gallery of Paintings*

118

Conclusion

127

Index

128

SILENT NIGHT
*oil on canvas, 18" × 24" (45.7cm × 61cm)*
*Collection of Mr. & Mrs. G. Usling, Canada*

# Introduction

For as long as I can remember, painting has been a part of my life. Early on, I painted for pleasure in my spare time. As I painted more, I knew that at some point I wanted to make painting my career. The one problem was that I felt my work wasn't of the professional standard I saw at art galleries and in art magazines. Any attempt to earn my living at painting would quickly result in the "starving in a garret" scenario. I enrolled in art college, planning to graduate in fine arts.

While at college, I noticed the paintings of today lacked the inner glow and light of the works of the Old Masters. So I studied the works of painters I admired and read everything I could about their working methods. I found many of the working methods and practices of the Masters were no longer being taught or used by today's artists. I started to use these methods in my own work and I immediately saw a difference.

Part of the reason artists had stopped using the methods employed by the Old Masters was that the paintings took months to finish due to the slow drying time of the paint. Now, thanks to the introduction of alkyd paints and mediums, effects that took months can be accomplished in a matter of days—using brilliant new colors the Old Masters could never have dreamed of. It is the combination of old ideas and new materials I'll share with you in this book.

One of the best ways to learn painting is by studying with an experienced artist. In this book you will look over my shoulder as I work on paintings, from the original sketch to the final signature. I will show you how to identify and solve potential problems before starting to paint so that your paintings will be successful. By following the methods shown in this book, your paintings *will* improve. The formula is simple: by creating successful paintings you'll paint more, and the more you paint, the better painter you will become.

I hope you'll paint with me as you read this book, trying the ideas and techniques shown. If you wish, you can copy the paintings in the book, but I believe you'll learn more if you do a painting of your own choosing, incorporating the methods shown here. Even though I am a realist painter, the methods shown in this book can be adapted to any style of painting. By following the basic concepts of composition, color, value and technique shown here, any painting, regardless of style or subject, can become a glowing oil painting.

# 1 Starting Out Right

Winston Churchill once said, "Give us the tools, and we will do the job." This chapter will deal with the tools you will need as an artist to "do the job" and how to use them to advantage in your paintings.

THE WATCHERS
*oil on canvas, 12" × 16" (30.5cm × 40.6cm)*

# Brushes

Brushes are one of the most important tools used by a painter. Without proper brushes it is impossible to achieve what you want, regardless of skill. A brush should be responsive to your wishes—it's frustrating not to be able to achieve the result you want because your brushes aren't up to the task.

Brushes are not only used to apply paint, but also to blend and remove it. Each type of brush serves a special purpose. The brushes used for oil painting can be placed into four categories: broad painting, detailing, blending and special brushes.

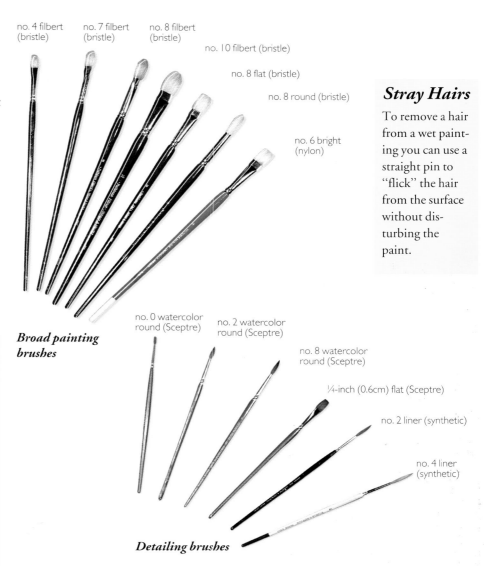

no. 4 filbert (bristle)
no. 7 filbert (bristle)
no. 8 filbert (bristle)
no. 10 filbert (bristle)
no. 8 flat (bristle)
no. 8 round (bristle)
no. 6 bright (nylon)

*Broad painting brushes*

no. 0 watercolor round (Sceptre)
no. 2 watercolor round (Sceptre)
no. 8 watercolor round (Sceptre)
¼-inch (0.6cm) flat (Sceptre)
no. 2 liner (synthetic)
no. 4 liner (synthetic)

*Detailing brushes*

## *Stray Hairs*

To remove a hair from a wet painting you can use a straight pin to "flick" the hair from the surface without disturbing the paint.

## *Cleaning Brushes*

Keeping your brushes clean isn't just good housekeeping, it's good economics. Good brushes are expensive and if they aren't looked after properly will quickly deteriorate to the point where they become unusable. This is the proper method to use when cleaning your brushes:

1. Wipe as much paint off the brush as possible with a rag or paper towel.
2. Rinse brush in mineral spirits and wipe clean.
3. Wash in warm (not hot) water with soap or artists' brush cleaner.
4. Repeat until no color comes out of the brush. Shape brush to original shape with fingers and stand on end to dry. (Never use a damp brush to apply oil paint.)

Oil paint mixed with Liquin or alkyd paint dries rapidly, so it is essential to clean your brushes after each painting session. If left overnight they will be impossible to clean by the morning. Rags and paper towels used to clean up should be removed from the studio and placed outside in a steel garbage can as they constitute a fire hazard. Rags saturated with linseed oil and mineral spirits can spontaneously combust, even without a source of ignition.

## BROAD PAINTING BRUSHES

Broad painting brushes are used for blocking in major shapes and covering the canvas quickly. They are made of natural bristle or synthetic fiber and come in four types: flat, bright, round and filbert. They are available in various sizes. I use filberts most as they combine the properties of the bright and round. A basic selection of broad painting brushes are no. 4, no. 7 and no. 10 filberts, a no. 8 flat and a no. 8 round. I use a no. 6 bright synthetic brush to "cut" into layers of paint. I find this brush indispensable when painting water. The synthetic flat can be used when painting water to either add or remove paint to produce ripples and waves. Bristle brushes are stiff and work the paint into the canvas rather than just leaving it sitting on top.

## DETAILING BRUSHES

I use watercolor brushes for working close to the canvas and find the short handles are more convenient. I use a no. 0, no. 2 and no. 6 round, a ¼-inch (0.6cm) flat and no. 2 and no. 4 rigger (or liner) brushes. The rounds are used for adding fine details, the small flat is used for small rectangular details such as windows and bricks and the riggers are invaluable when painting grasses or the fine branches on trees.

I find that synthetic brushes work as well as sable and are substantially cheaper—the abrasive surface of the canvas can wear the point of a genuine sable brush very quickly. Brushes made from a combination of synthetic and sable, such as Winsor & Newton's Sceptre line, are a good compromise.

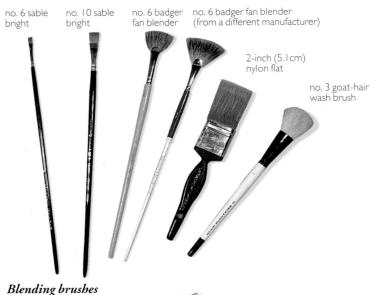

no. 6 sable bright    no. 10 sable bright    no. 6 badger fan blender    no. 6 badger fan blender (from a different manufacturer)

2-inch (5.1cm) nylon flat

no. 3 goat-hair wash brush

*Blending brushes*

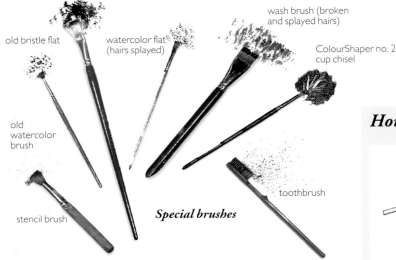

old bristle flat

watercolor flat (hairs splayed)

wash brush (broken and splayed hairs)

ColourShaper no. 2 cup chisel

old watercolor brush

stencil brush

toothbrush

*Special brushes*

## Brush Sizes Vary

Remember, brush sizes can vary depending on the maker.

# Supports

I prefer to work on stretched canvas with a fine weave, as the fine detail in my paintings is hard to achieve on a rough canvas. I have used Masonite but find that I miss the texture and spring of canvas. Masonite is also very heavy if used for large paintings. Canvas boards are fine for quick studies and work not intended to be permanent, but are not suitable for professional-quality paintings as they deteriorate over time.

## *How to Make a Mahlstick*

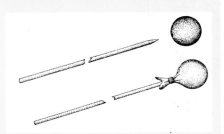

## BLENDING BRUSHES

Use these brushes for blending, *never* for painting, and clean them immediately after use so they will remain soft. I use four types of blending brushes: genuine sable brights for blending small areas and softening edges between colors or values; badger fan blenders for larger areas and painting skies; large, synthetic, flat brushes similar to a housepainter's brush to smooth out a large area of paint; and watercolor wash brushes to blend and soften areas or remove excess color. The watercolor brushes have one drawback—they tend to lose hair, but I haven't found any other brushes that give me the soft blends I require.

## SPECIAL BRUSHES

Most of these are brushes that have long since lost their original properties. Some are old watercolor flats and rounds that have worn into their present state. Others I have altered by pounding them on a hard surface, crimping the ferrule with pliers or cutting the bristles. I use these brushes to develop texture and to indicate grass or foliage. I use toothbrushes and stencil brushes to "spatter" paint, creating textures such as sand. A new product called a ColourShaper is a useful addition to the special brushes category: ColourShapers consist of a piece of shaped silicon rubber that acts as a squeegee, pushing paint aside to reveal the underpainting. They can be used to show branches or tree trunks, or to add texture.

The mahlstick is a tool artists have used since at least the Renaissance and very likely before that. It allows you to do detail work on a wet painting without touching the paint. It can also be used to draw straight lines and as a drawing aid to transfer angles and measurements from the subject to the canvas. While you can buy one in art supply shops, it's easy to make your own. All you need is a piece of wooden doweling ¼ inch (0.6cm) in diameter and a small rubber ball or golf ball. Drill a hole halfway through the ball, insert the doweling and glue it into place. When dry, sand the doweling and rub it with linseed oil to keep paint from sinking in and to give it a smooth finish. Then cover the ball with a piece of chamois or cloth.

# Oil Paint

I primarily use Winsor & Newton Artists' oils, supplemented with a few colors from other manufacturers. All colors I use in my paintings are artist-quality paints. I never use budget or student brands. While artist-quality paints are initially more expensive, they're actually less expensive in the long run as the pigments are stronger, so you use less paint. They also add to the brightness and clarity of the finished painting.

I have found some of these colors—listed below—come very close to producing a pure spectrum. As you can see, the spectrum produced by these colors is very striking. When mixed with white, the brilliance of the colors is evident. In the white area at the bottom of the example you'll notice that the tints mix well and don't produce muddy colors. You can obtain excellent darks by mixing Winsor Red and Winsor Blue. Violet can be mixed using French Ultramarine and Alizarin Crimson. If you wish to have a premixed dark, either Burnt Umber or

Ivory Black could be added, but I get excellent results just using the colors I mix. With the addition of Titanium White, this is a good list of basic colors for someone just starting to paint. An added bonus is that all the colors except for the Alizarin Crimson, Cadmium Yellow and French Ultramarine are series 1 colors—the least expensive category.

On the following pages are the colors I use in my paintings. I have grouped them by color family to help you when you start to construct color pools (see chapter two) for your paintings. You can also see the relative strength of the colors and their transparency before being mixed with white. I have mixed them with Titanium White at the bottom of each chart to show their tinting strengths. If you repeat this exercise you will learn a lot about the properties of each color. When completed, you will have a set of reference charts that will show the actual colors; this will be far more accurate than

the printed charts distributed by the manufacturers.

## ALKYD COLORS

Alkyds are the newest type of oil color to arrive in the art stores. They use the same pigments as oil paint but are ground in an alkyd medium. They are fully compatible with traditional oil paint, but offer different properties. Chapter three (pages 63-64) deals with alkyds in more detail.

## MEDIUMS

There is more mystery and misinformation surrounding painting mediums than anything else in oil painting. Some mediums are reputed to have been handed down from the Old Masters and will allow you to paint like Rubens or Raphael. Unfortunately, the paintings of the Old Masters weren't due to something as simple as a magic medium, but to years of apprenticeship and training. I have seen some "wondrous" painting

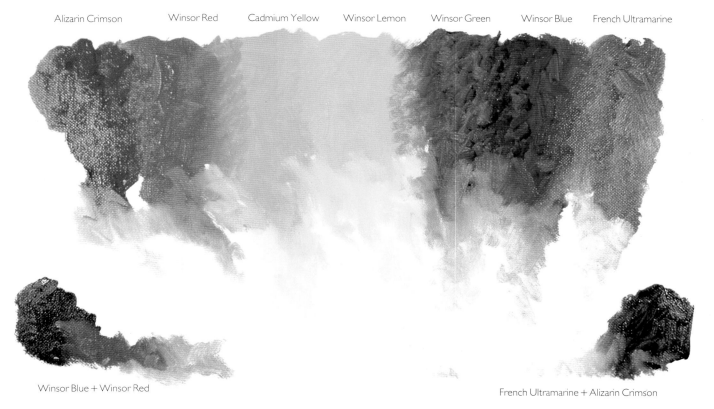

Alizarin Crimson · Winsor Red · Cadmium Yellow · Winsor Lemon · Winsor Green · Winsor Blue · French Ultramarine

Winsor Blue + Winsor Red

French Ultramarine + Alizarin Crimson

*Color chart using limited palette of colors*

mediums over the years. During one workshop, a student opened a bottle of "magic elixir" and proceeded to empty the room with its smell. It turned out to be a mixture of cream, eggs, oil and turpentine, which of course had turned rancid.

The only purpose of a painting medium is to thin the paint enough to help in its application. Some brands of oil paint contain enough oil so as to make the use of additional medium unnecessary. I only use two mediums in my paintings: Liquin, an alkyd painting medium manufactured by Winsor & Newton that improves the flow of the paint, speeds drying and increases the brightness of the colors; and if I want an area to remain workable for a couple of days, I use a traditional medium of one part stand oil and two parts turpentine. Stand oil is a modified form of linseed oil. It is about the same viscosity as honey and is the least yellowing form of linseed oil. Mixed with either mineral spirits or turpentine and used as a painting medium, it retards drying and improves the flow of paint.

You should only use enough medium to make the paint workable. If you add too much your paint will turn "soupy" and the intensity of the colors will be destroyed. I am surprised by the number of artists who buy premium paint and then dilute it with medium until it is the equivalent of a student brand. If you are used to working with a more fluid paint, once you get used to working with less medium you will have greater control and be able to blend and soften edges far more easily than you could with the thinner paint. Also, the more medium you add to paint, the more chance it has of cracking and yellowing as it ages.

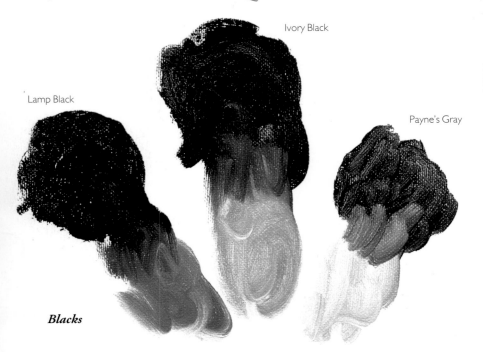

Lamp Black

Ivory Black

Payne's Gray

**Blacks**

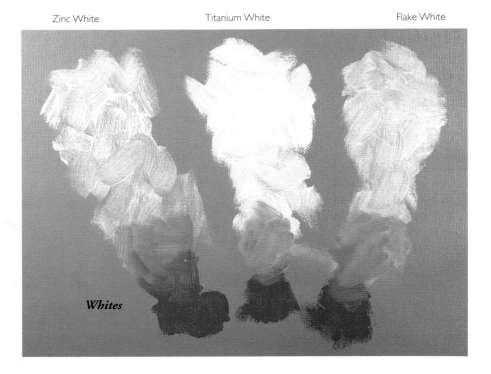

Zinc White

Titanium White

Flake White

**Whites**

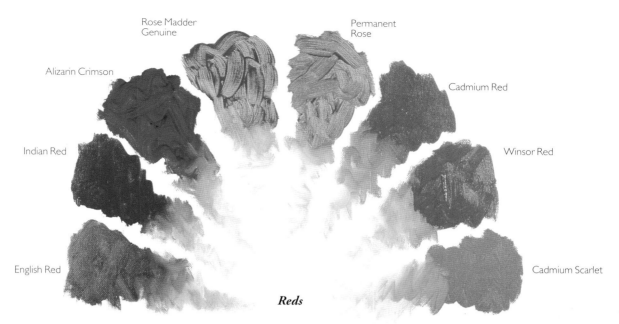

Rose Madder
Genuine

Permanent
Rose

Alizarin Crimson

Cadmium Red

Indian Red

Winsor Red

English Red

Cadmium Scarlet

**Reds**

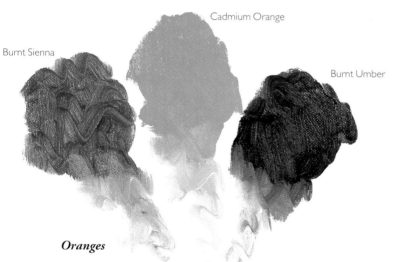

Cadmium Orange

Burnt Sienna

Burnt Umber

**Oranges**

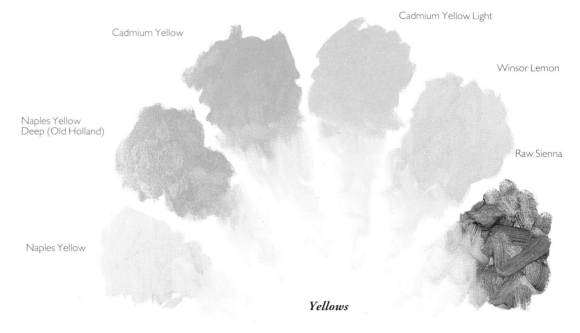

Cadmium Yellow Light

Cadmium Yellow

Winsor Lemon

Naples Yellow
Deep (Old Holland)

Raw Sienna

Naples Yellow

**Yellows**

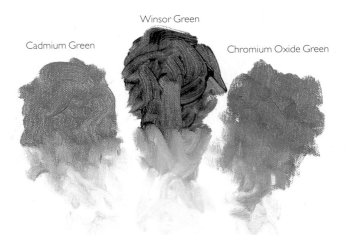

Cadmium Green

Winsor Green

Chromium Oxide Green

**Greens**

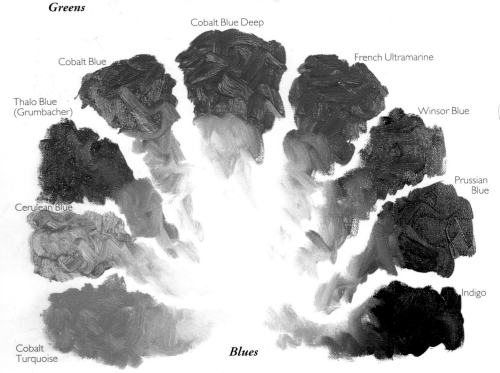

Cobalt Blue

Cobalt Blue Deep

French Ultramarine

Thalo Blue
(Grumbacher)

Winsor Blue

Cerulean Blue

Prussian
Blue

Cobalt
Turquoise

Indigo

**Blues**

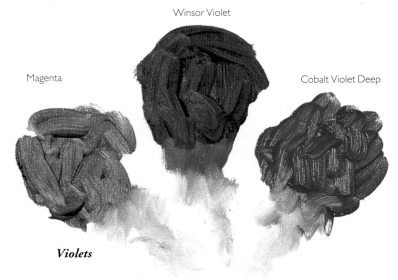

Winsor Violet

Magenta

Cobalt Violet Deep

**Violets**

## Lead Paint Precautions

There is a lot of misinformation about the use of lead in artist's paint. Lead is toxic. However, if reasonable care is taken in its use, there isn't any reason why it shouldn't be used. The reason for using lead in oil painting is twofold: First, it reflects light differently than either titanium or zinc, imparting a glow to the painting. Second, it has a low absorption of oil, making it suitable for underpainting and lessening the chance of the paint cracking or yellowing over time. Here are some safety guidelines you should practice no matter what type of paint you're working with. Just because many pigments aren't rated as toxic doesn't mean they are exactly gourmet fare!

- Never eat, drink or smoke when painting.
- Avoid getting paint on your hands.
- Wash your hands when finished.
- Never sand a painting done with lead Cadmium or Cobalt pigments.
- Store the paint where children and pets can't reach it.
- Don't put your brush or fingers in your mouth while working.
- Never burn a painting that contains lead pigments.

# Palette

My palette is a 13″ × 18″ (30cm × 45.7cm) sheet of plate glass painted a middle-value gray on the reverse to help in judging my values when painting. I also have a small value chart painted on it to check the values of the colors I am using. A glass palette is easily cleaned with a scraper, even if colors have dried. I clean my palette after each painting session as I like to be able to start work without having to waste time cleaning up. I never use disposable paper palettes because they tend to tear when you mix paint and the white surface makes it hard to judge values.

## LAYING OUT COLORS

Once I'm working on a painting, I don't like to stop and mix colors. I premix a generous amount of all the colors I think I'll need before starting to paint. This allows me to paint without breaking my natural rhythm; there is nothing more annoying than running out of paint while you are painting. This is especially important when painting large areas like skies or water. When I did a large 5′ × 12′ (1.5m × 3.7m) painting for a client a couple of years ago, I purchased empty tubes and filled them with my premixed colors. Even though the painting took over a month to complete, I always had a supply of fresh color for each session and didn't lose time trying to match colors.

When laying out my palette, I mix the Titanium White first while the palette is clean, adding just enough medium to make it workable. I start with white so I won't accidentally mix other colors into it—it only takes a small amount of another color to ruin white. When I finish mixing the white I move it to the corner of my palette and put out the other colors I will be using. I then mix the colors I'll need for the painting session, again only adding enough medium to the colors to make them workable. If I'm mixing the colors with the premixed white, there's usually enough medium in the white, so I don't have to add any additional medium.

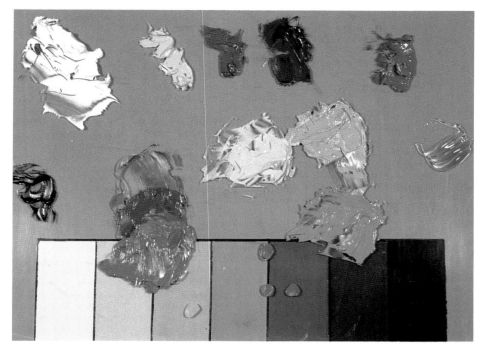

My palette.

I only put out the colors I know I will be using in each session, so the setup of my palette varies. However, I do follow a general plan. I keep the Titanium White and any yellows at the top left corner of the palette. I then run the pure colors, starting with the yellows, from left to right across the top. I run any earth colors or black down the left side. I do this to avoid contaminating the lighter colors with the intense ones. A color's intensity can be destroyed by adding even a small amount of its complementary color. I put a small amount of Liquin on the palette so I can add it to any colors needing more medium without having to open the bottle.

I always mix my colors with a palette knife. Not only does the knife blend the color better than a brush, it is also easier to clean. If you use a brush to mix paint, the paint works up into the ferrule of the brush and is almost impossible to remove, reappearing when you try to mix other colors. When painting I often use a brush to mix two colors on the palette or painting together, but this is done with the tip of the brush.

## UNDERSTANDING COLOR TERMS

Every profession has its own set of terms, and painters aren't any different. Here is an explanation of three terms I will use throughout this book.

*Hue* describes a color, such as red, blue, yellow, green.

*Chroma* is the intensity or dullness of a color. A pure color like Cadmium Orange is a high-chroma orange, while Burnt Sienna is a low-chroma orange. English Red is a low-chroma red and Cadmium Red is a high-chroma red.

*Value* is the range between dark and light. White is the lightest value and black the darkest.

These concepts are straightforward until you begin to mix colors. Then you realize that if you adjust the hue of a color, you also change its chroma and value; conversely, when you change the value of a color, you will affect the hue and chroma. All three properties are interrelated.

# The Studio

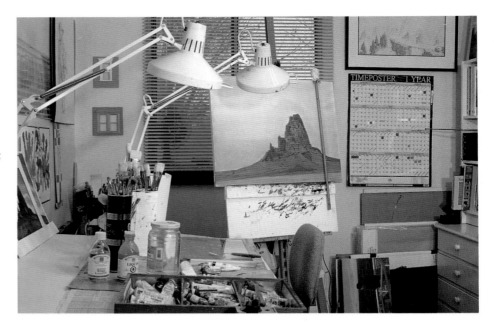

Some studios look like a crime scene, while others closely resemble a laboratory. My studio fits somewhere in-between. I like things organized to the point that I don't waste time looking for them, but not so neat that it becomes a showplace I would be afraid to use. I converted a small bedroom in my home for my studio. The advantage of a home-based studio is that you can start early and work late. While the ideal is to have a place set aside just for painting, sometimes this isn't possible. In my early years of painting my studio was like the stars: It came out at night! However, this didn't deter me from painting! The lack of a proper studio is only an excuse for not painting, not a good reason.

## STAND BACK

I work standing up because I feel more comfortable and I can easily step back to see how the overall effect of the painting is working. My studio is arranged to take this into account. I have an adjustable drafting chair that I use if I will be working on an area of detail for some time and wish to sit; however, I still stop every ten or fifteen minutes and check how the painting looks from a distance. I learned this the hard way when, after working on the details of a distant shoreline, I realized that everything was in the wrong scale for the rest of the painting. I had to wipe it out and totally repaint it.

## KEEP IT CONVENIENT

I'm left-handed, so my workspace is organized to allow for that. I have a large 36″ × 48″ (91.4cm × 121.9cm) drawing table that I cover with a sheet of plastic and newspapers when painting. Its height is adjusted so I don't have to bend over to mix colors, and it is large enough that I can have all my paints, mediums, solvents and brushes within easy reach. My drafting chair is adjustable so I can sit comfortably at the drawing table or easel.

## MULTIPLE LIGHT SOURCES

The major source of light in my studio is an overhead fluorescent fixture with Verilux (color-corrected) tubes. I also have two adjustable lights on the drawing table, which are a mixture of incandescent 60-watt bulbs and a six-inch circular fluorescent. One light illuminates my palette and the other illuminates my painting. I find that if I use only the Verilux lights the colors look too cool when viewed in galleries or homes where the lighting is warmer.

## GOOD VENTILATION

When working with oils you need good ventilation to remove the fumes from the solvents. In my studio I have a fan in the window and keep the window open when working. Even with proper ventilation I am careful with my solvents and keep them covered when I am not using them. (They also make a proper mess if spilled.)

## STUDIO FURNITURE

Basic studio furniture is quite inexpensive and can often be purchased secondhand or handmade. I have bookcases for reference books and a chest of drawers to store supplies. One storage unit is an old typing table with a toolbox sitting on top that holds all my pens and pencils and other small items. My "wall unit" is a dresser with a bookcase on top, painted to match.

The easel is one item you will probably have to buy new, unless you are lucky in finding one secondhand or skilled enough to make one. I prefer a wooden easel over a metal one. Ease of adjustment and securing your canvas are the most important factors in choosing an easel. Trying to paint fine detail on a shaky easel isn't recommended for your mental health. Keep your painting at the level where you don't have to bend over to work. Besides being bad for your posture, you will tire quickly.

A studio is very personal. An artist can no more use another artist's studio than wear his or her shoes. Each artist's studio will be an extension of his or her personality and creativity. It's up to you to decide what your requirements are and then design your studio to take that into account. Remember, you want to use all your physical and mental energy in painting, not in fighting with your working environment.

# Planning Your Paintings to Solve Problems Early

In order to avoid frustration and disappointment later on, it's essential to plan your paintings. Illustrators, who have to deliver top-quality artwork on a tight schedule, plan their work so they won't run into problems later that could cause them to miss a deadline. Fine artists often feel they will lose their spontaneity by following a structured plan. I find the opposite to be true: By planning the painting you can try different compositions, colors and formats you would be wary of trying on a large canvas. The investment of time and materials spent in planning is minimal, whereas on a painting you could ruin a canvas or destroy a day's work.

### Composition Rules for Painting

Here are some basic rules of composition you can follow to produce an effective design.

 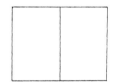 
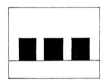 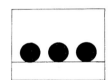 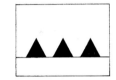

As soon as you draw a line dividing your paper or canvas, you have taken the first step in creating a painting. Where you place the line will establish the basic division of areas in your painting. The above examples divide the space, but break one of the cardinal rules of design: They divide the space equally. In a painting the division of space should never be equal.

Just as in the previous illustrations showing the division of space, the same rule applies when placing objects in a picture. In these examples, all the shapes are the same size and lined up in a row. Good composition for a shooting gallery, but not for a painting.

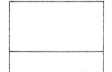 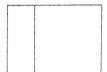 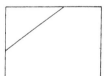

In these examples I have moved the dividing lines. You can see there's already something happening. Even though there are still only two areas, because they vary in size they make the space interesting.

By altering the size of the shapes and their value you can use these basic forms to build a painting. By allowing the forms to overlap, you also create the illusion of depth.

Using the divisions created in the above illustrations, I have done some thumbnail sketches to show how the division of space can be used to create a painting.

The center of interest in a picture should very seldom be at the center (one of the few times this rule is broken is for religious subjects). While there are many ways to establish a center of interest, one that is quite effective is to divide the canvas into three equal sections both horizontally and vertically, then place your center of interest at one of the points where the lines cross.

# 2 *Glowing Colors for Luminous Effects*

Achieving brilliance and depth of color in your paintings may seem like an elusive and mysterious process; in fact, the techniques are quite easy once you understand the basic principles of value and color. In this chapter I will show you how to select colors and use them in your paintings.

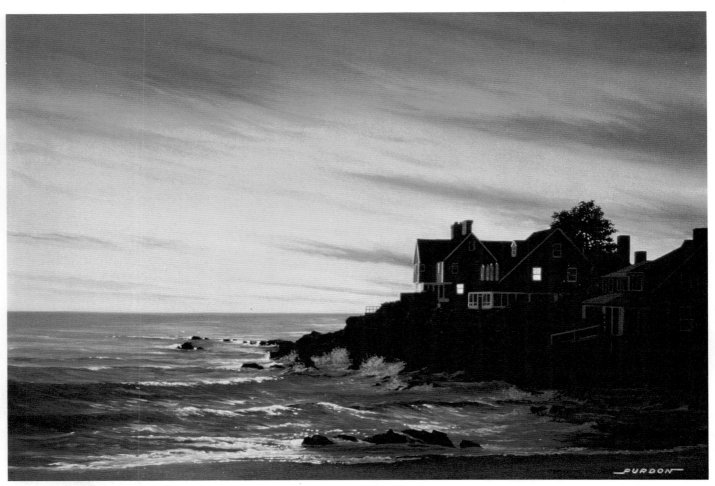

DAYBREAK ON THE COAST
*oil on canvas, 22" × 28" (55.9cm × 71.1cm)*
*Collection of Mr. & Mrs. Kevin Moloney, Canada*

# Value

On page 17 I mentioned three properties of color: hue, chroma and value. Of these properties, value is the most important. If the values in your painting are correct, the painting will work. Value is the framework on which to build your paintings. The skillful use of values can make your colors appear even brighter and more intense than they are, giving the effect of light coming from within your paintings.

You are accustomed to seeing values every day. A black-and-white photograph is a value study; all the information is given without the use of color, just black, white and many shades of gray. When painting, especially if you are new to working with values, it helps to have a value chart, like the one on the next page, to use for reference. When making a value chart, the number of steps between the lightest and darkest value is a matter of choice; I find it easiest to use eight steps, with white as number 1 and black as number 8.

Every color has a *home value*. When you adjust it, you will change either the hue or chroma. Yellow has a home value of between 2 and 3, depending on the chroma (Cadmium Yellow has a darker value than Lemon Yellow). To find the home value of a color, place it on a value chart and squint at it. It should sink into the value square it is placed on. If the color jumps out of the square, it is the wrong value. Move the color up or down the chart and squint again. It takes a little practice, but once you master it, you will be amazed at how closely you can match values.

Red has a lower home value than yellow, so if you want to increase its value, you must either add white or a lighter color, changing both its hue and chroma. If you wish to change the chroma of a color without changing the value, mix it with the same value gray. The chroma or intensity will be lessened, but the value will remain the same.

## MAKING LIGHT VALUES LOOK LIGHTER

When painting from life, remember that a painting is viewed by reflected light; the

Remember that values are *not* color, only how light or dark an object is. An object with a value of six can be red, yellow or blue.

This yellow is a value no. 3. If you place a value no. 3 color on a value no. 3 gray and look at it through slightly closed eyes, you will see that the yellow sinks into the gray. Use this method to determine the value of any color. Sometimes the color will be in between two values, so you would call it a value 5½ or value 5.5.

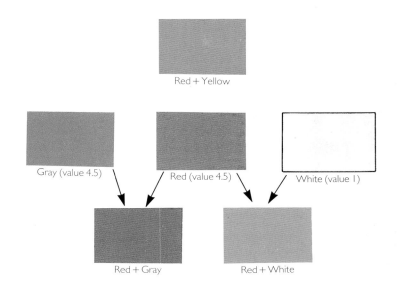

Red + Yellow

Gray (value 4.5)　　　Red (value 4.5)　　　White (value 1)

Red + Gray　　　Red + White

The red shown in the center of this chart has a home value of 4.5. If I change its value I will also change its chroma and hue. If I try to lighten it with yellow (value 3), it changes the hue. When I add white (value 1) it lightens the value, but reduces the chroma. Whenever you adjust value you change the other properties as well. If a gray of the same value is added to a color it will alter the chroma and hue, but the value will remain the same.

Value 2　　　　　　　　　　　　Value 7

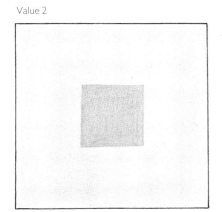 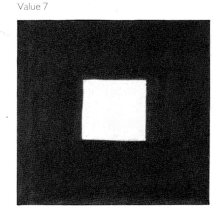

Values can look darker or lighter than they actually are, depending on the value of the surrounding area. This is a value no. 3 square on a value no. 2 and value no. 7 background. The square looks lighter on the no. 7 background.

value range of the painting can't match the range of your subject since there is no way to paint the brilliance of the sun. White paint is the lightest value you have, so you must make adjustments for this when painting. A good trick to remember is that a value will look brighter against a darker value. In the squares at right, a no. 3 value is shown against a no. 2 and a no. 7 square. You will notice that the value no. 3 square looks brighter on the value no. 7 background. This effect can be used when painting an evening sky: If the land is value no. 6, 7 or 8, even a value 3 sky will look bright.

## LIMITED VALUE RANGES

You've probably heard the terms *high key* or *low key* in conjunction with painting. A high-key painting is one done using lighter values, while a low-key painting is done in darker values. When working in a selected key, check your values often, as it is easy to add colors that are too dark or too light.

The only time you will use the full range of eight values in a painting is on a sunny day, or under a bright, artificial light. Normally you will be working with a limited range of values. In the following illustrations I have painted the same scene using different value ranges. By limiting the value range you can adjust the mood and effect of light in your painting. The lights on the shoreline in the last study were added with white (value 1), while the rest of the painting was done using values 5 through 8—this is what "turns on" the lights. If you check the value of the skies in some of the evening paintings throughout this book, you will be surprised that even though they look bright, they are quite reduced in value.

You should never use a full range of values in the middle ground or background of your painting. As you move further away from the foreground, you start to lose the higher and lower values. This effect is called *atmospheric perspective*. In the first illustration notice there is hardly any separation in the values of the sky and the distant hills. If the mist thickened, you would lose the hills completely and the background would be one value. Air has density and absorbs light; it isn't totally transparent.

*Misty morning* values 2 to 4

*Bright sun* values 1 to 8

*Early evening* values 3 to 8

*Late evening* values 5 to 8 (plus value 1 for lights)

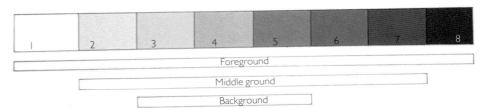

The scene above has been painted using several value schemes to give the effect of different times of day. The chart below the value scale illustrates how the range of values lessens as you move toward the background in a painting—you should never have the extremes of value in the middle or background of a painting.

## LIGHT AND SHADOW

When the intensity of the light changes, it not only changes the number of values in a painting, it also changes the relationship between light and shadow. In full sunlight, the difference between the side of an object lit by the sun and the side in shadow is three steps of value. For example, if the object is a white box, the sunlit side would be value 1 and the shadow side would be value 4. This relationship will apply to *all* objects in the foreground. In full sunlight, if the sunlit side of an object is value 5, the shadow side will be value 8 (black). As the intensity of light decreases, so does the contrast of the values. The same white box on a hazy day will only have a jump of two values between the light and shade. As the light becomes more diffused, the difference will disappear completely. In addition, as you move further away from the foreground, atmospheric perspective lessens the difference in values between the light side and shadow side. However, all objects on that plane should have the same relationship of light-to-dark values. The contrast of values must be consistent throughout each plane of the painting. Once you understand values, you can manipulate them to create the lighting effect or mood you want in your painting.

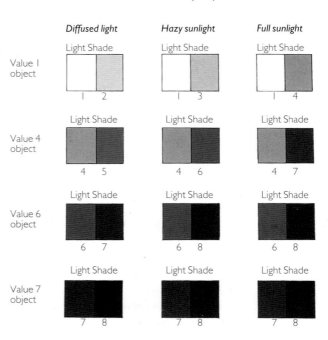

Depending on the level of illumination, the difference between the side of an object receiving light and the shadow side will vary from three degrees of value to the same value. When you are using low values (6 or 7) the jump in value range will lessen between the lit side and shadow side because the shadow can never get any darker than value 8 (black).

# Keep Your Colors Brilliant

When you open a tube of paint, especially a high-intensity (high-chroma) color, look at how brilliant the color is—a good quality Cadmium Red or Cadmium Yellow is so bright it almost hurts your eyes. So why do the same colors lose that intensity in your paintings? The answer is simple: Most artists destroy the brilliance of their colors by overmixing them with other colors, adding too much medium or working under the mistaken idea that adding white to a color makes it brighter.

When you add white to Cadmium Red it becomes not a brighter red but a cooler pink. It would be a more natural transition to add Cadmium Yellow to Cadmium Red. Yellow successfully brightens red, but you must take into account that it also shifts it toward orange, altering its hue. Use this technique if you require a highlight on a bright red object and don't want to weaken the warmth of the red. You can still use a small amount of white in the center of the highlight if necessary, blending it into the mixture of Cadmium Red and Cadmium Yellow for a more natural transition.

Other colors can be successfully lightened by adding the color next to them on the color wheel, if that color is lighter. For example, you can use yellow to produce the highlights on green foliage, giving the effect of sunlight. If you used white, the resulting color would be a pastel green.

### Take It From a Master

Rembrandt—known for his portrayal of light—was a value painter. Study some of his paintings: You will realize there isn't a lot of color in them. What makes them dramatic is his masterful control of *values*.

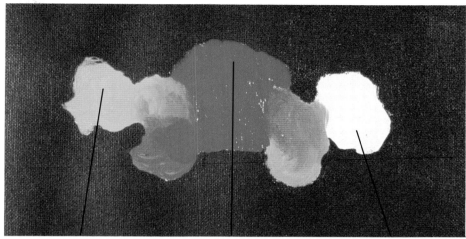

Cadmium Yellow      Cadmium Red      Titanium White

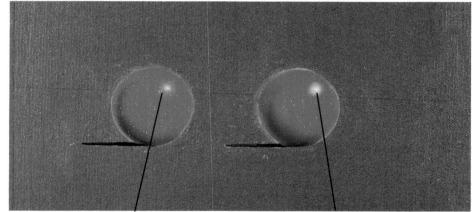

Highlight painted with Cadmium Yellow + white      Highlight painted with white only

## BLUE AND YELLOW DON'T ALWAYS MAKE GREEN

Dyes and inks have been developed that are pure red, blue and yellow for use in the commercial art field and in printing. When mixed, these colors will perform according to all the rules of color mixing: Blue and red make violet, yellow and red make orange, and blue and yellow make green. Unfortunately, these colors are dyes, not pigments. While they serve the purposes of the printing industry, they aren't lightfast and will start to fade in a matter of days if exposed to sunlight. The manufacturers of artist-quality paints are concerned with the permanence of their colors and therefore don't use any of these dyes in the manufacture of their paint. Pigments differ from dyes in that they're solids and have body. Pigments can't be altered to produce the pure colors of the printer's dyes. Even though the theory states that red and blue make violet, with artist's colors the violet will not be a pure violet, but one shifting to red or blue. Depending on the warmth of the red or blue, it might even look more like a gray than a violet. Cadmium Scarlet and Ultramarine Blue combine to make a gray that's especially suitable for use in painting skies, but is not a violet. Once you realize the results of mixing artist's colors are inconsistent with the rules of color you learned in school, you can then look at color mixing in a totally new way.

# Color Pooling

Like most artists, every trip I make to the art store usually results in the purchase of a new color. If your paint box is like mine, you have a large selection of colors, some never opened, others used once and cast aside. Each artist develops his or her own "hit parade" of colors. When you work this way you are painting by formula. When you need a sky blue you have a favorite mixture you know will work, so you just mix it up and start to paint. Eventually your paintings will all start to look the same and you are no longer challenged to think about new colors. That's what happened to me. So one day while looking at the number of colors I had accumulated, I decided there must be a way to use them in my paintings and expand my range of colors. I came up with what I call *color pooling*.

A color pool can be made of two, three or four colors, plus white. I find that once you exceed four colors your mixtures start to get muddy. These serve as the core colors used in the overall construction of your painting, but don't keep you from adding a specific color for a local effect.

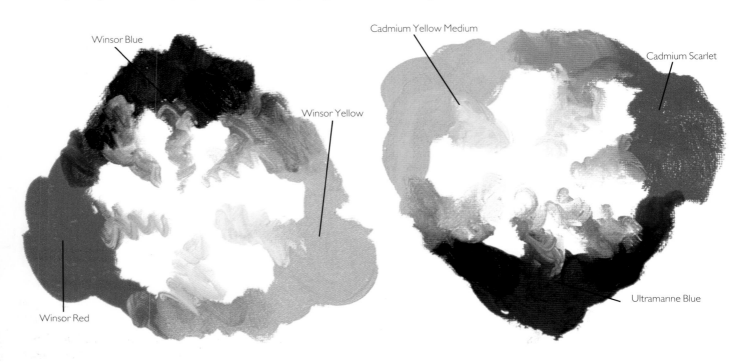

## WINSOR RED, WINSOR YELLOW, WINSOR BLUE

Winsor colors are some of the purest and brightest colors available. Because of their high chroma and purity they produce very pure secondary colors (orange, green and violet). Colors similar to the Winsor colors are now produced by other manufacturers, but are sold under different names. If you check the labels on other brands of paint for the pigments listed below, you should be able to find colors very similar to the Winsor & Newton ones. The pigments used in the Winsor colors are:

> Winsor Red-*Arylamide Red Naphthol (AS)*
> Winsor Yellow-*Arylamide Yellow*
> Winsor Blue-*Copper Phthalocyanine*

## CADMIUM SCARLET, CADMIUM YELLOW MEDIUM, ULTRAMARINE BLUE

The color pool above still uses red, yellow and blue, but this time the colors are Cadmium Scarlet, Cadmium Yellow Medium and Ultramarine Blue. The secondary colors in this pool aren't as pure as the ones in the previous example because both the Cadmium Yellow Medium and the Ultramarine Blue contain some red. While the mixtures in the right color pool don't have the purity of those in the left pool, they do have a special quality all of their own. Using these colors would produce a painting with a different color balance than the Winsor colors.

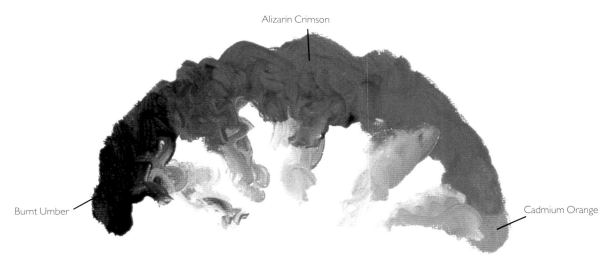

Alizarin Crimson

Burnt Umber

Cadmium Orange

# Identify Color Roots

This process is very simple when you're working with colors that are very clearly red, yellow and blue, but what about colors that aren't as easy to identify? Look at each color and decide what its real color is in very simple terms: Is it a red, yellow, blue, green, etc.? Don't get involved with detailed analysis. Avoid labeling a color "reddish orange"—choose red or orange instead, depending on which color it's closer to. By applying this theory to your color pools, you start to see things in a totally different way.

Some colors give you a hint in their name as to where they fall in the order of things, such as Indian Red, Indigo Blue and Naples Yellow. Others like Burnt Umber, Raw Sienna and Burnt Sienna aren't so easy. If a color is very dark, such as Burnt Umber, adding some white to it will make it easier to determine its root color. Most of the brown pigments are low-chroma reds or oranges. Burnt Umber is a very low-chroma red, a fact that becomes apparent when you mix it with another low chroma red, Alizarin Crimson. The Burnt Umber darkens the Alizarin Crimson, but doesn't dull the hue the way black would. If you mix Cadmium Orange with Alizarin Crimson, you lighten it without weakening its intensity, because orange is the color next to red on the color wheel.

## Take a Chance

The purpose of color pooling is to allow you to explore new ways of using colors, so don't be afraid to take a chance. Since you work with color pools prior to doing an actual painting, you can experiment by mixing unlikely colors to see the effects. The worst that can happen is that you'll use a small amount of paint and time; you might even get a pleasant surprise! I keep my color pools and often look them over when I'm planning a painting to see if any of them will give me the colors I'm looking for.

# The Agathlan

## Materials Used in Finished Painting

**OIL PAINTS**
- Cadmium Scarlet
- Indian Red
- Naples Yellow
- Winsor Violet
- Indigo
- Titanium White
- Burnt Sienna

**ACRYLIC PAINTS (Optional)**
- Burnt Sienna
- Dioxazine Purple (substitute for Winsor Violet)

**BRUSHES**
- no. 4 bristle filbert
- no. 7 bristle filbert
- no. 0 watercolor round
- no. 2 watercolor round
- no. 8 watercolor round
- no. 3 Winsor & Newton goat-hair wash brush
- no. 6 sable bright
- old 1-inch (2.5cm) watercolor flat (well worn and hairs splayed)
- old no. 10 watercolor round (well worn and hairs splayed)
- 2-inch (5.1cm) housepainter's brush

**OTHER**
- 22" × 28" (55.9cm × 71.1cm) stretched and prepared fine-weave canvas
- carbon or charcoal pencil
- Liquin

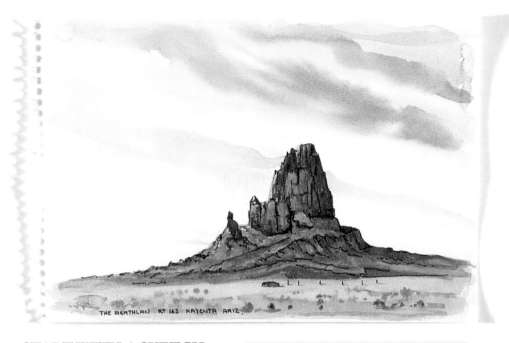

THE AGATHLAN   RT 163   KAYENTA ARIZ.

## 1. START WITH A SKETCH

While traveling in the Southwest, I did some sketches of the various rock formations and some studies of the morning and evening skies. I was especially impressed by the glowing light of the sky contrasting with the dark shapes of the rocks. I wanted to remember those effects so I could reproduce them in a painting. Rather than taking a photograph and copying it back in my studio, I made this watercolor sketch of a rock formation near Kayenta, Arizona, to remind me of the scene.

## Painting From Your Own Experience

When painting a new location, you must take into consideration the natural conditions that will affect the light and color. The colors, quality of sunlight and the effects of atmospheric perspective in a desert scene will be totally different from those in a misty Scottish landscape (see demonstration three). It helps to know the geographical and climatic factors that contribute to the unique quality of each landscape. By considering these influences you will capture the unique feeling of the place. For this reason, I only paint places I have visited personally. To paint a location I haven't experienced myself would mean I could do little more than copy a photograph.

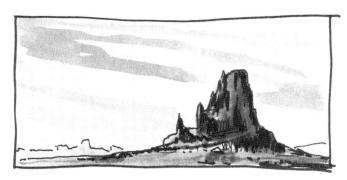
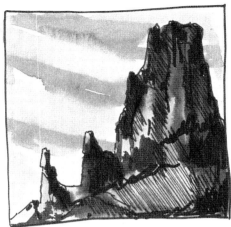
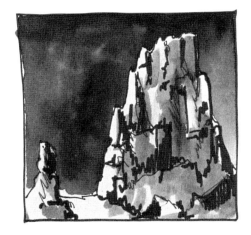
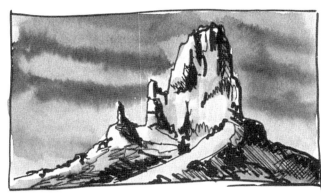
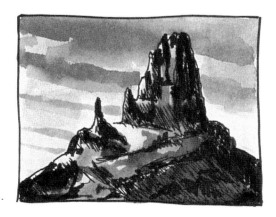
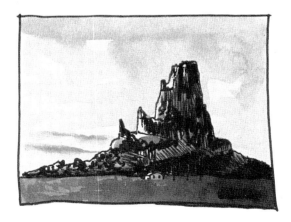

## 2. FIND THE BEST COMPOSITION

I often do two or three pages of these black-and-white compositional "roughs" until something clicks. You can see I don't spend a lot of time on the details; I'm only interested in the major shapes and areas of light and dark. I used pen-and-ink washes for the above studies, but I often use pencil or marker. These aren't meant to be finished pieces of art. I think the rectangular format on the bottom right works best for this scene, so I decide on a medium-size canvas, 22″ × 28″ (55.9cm × 71.1cm). There are several effective sketches on this page, so I'll save it as a starting-off point for future paintings.

## 3. EXPERIMENT WITH COLOR POOLS

Because I won't be copying the colors from the original sketch, I now have to decide on the colors I will use in the painting. I don't want to use the usual sunset of reds and yellows—I want more dramatic values and colors. Using a sheet from a canvas pad, I do several combinations of color pools to see which ones will give me the effects I want. I add and delete colors until I have a grouping I like.

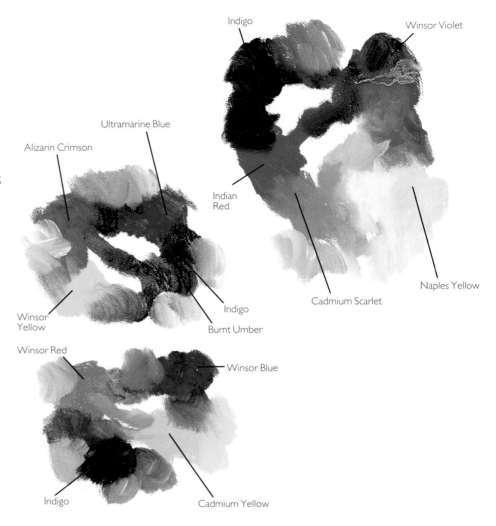

Indigo

Winsor Violet

Ultramarine Blue

Alizarin Crimson

Indian Red

Naples Yellow

Cadmium Scarlet

Winsor Yellow

Indigo

Burnt Umber

Winsor Red

Winsor Blue

Indigo

Cadmium Yellow

## 4. TEST YOUR COLORS WITH A COLOR STUDY

I then make a quick color study to see how the colors—Cadmium Scarlet, Indian Red, Naples Yellow, Winsor Violet and Indigo—will work prior to starting the painting. I don't worry about details, concentrating instead on the shapes and colors. I like the results of the color rough and decide to use these colors for the painting. By completing the composition value studies and color pools, you have found solutions to the major problems of the painting. You can now move to your canvas with confidence.

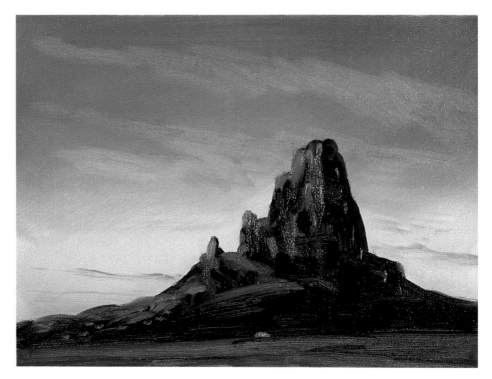

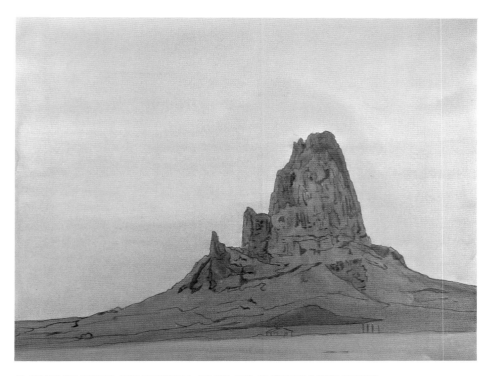

## 5. TONE THE GROUND AND BLOCK IN SHAPES

I seldom work on a white canvas, preferring to paint on a toned ground. I find this especially helpful when trying to produce dramatic lighting effects. The advantage of using a ground color is that you can introduce a color into the painting that isn't part of the original color pool. When the ground color is allowed to show through the paint layers, it produces effects that couldn't be achieved by mixing colors on the palette. It also acts as a unifying tone for the whole painting. Because the lighting in this painting is warm, use Burnt Sienna for the ground. The canvas can be toned with oil paint mixed with Liquin and mineral spirits, or, if you want to speed the drying time, you can use either alkyd or acrylic. Cover the canvas with a thin, transparent layer, using a 2-inch (5.1cm) housepainter's brush. When dry, lightly transfer the drawing onto the canvas using a carbon or charcoal pencil; graphite bleeds through the painting over time, so it should never be used. When you are satisfied with the drawing, go over it with Winsor Violet oil paint diluted with Liquin and mineral spirits. If you used acrylic to tone the ground you could go over the drawing with thinned Dioxazine Purple acrylic instead of the oil paint (Winsor Violet isn't available in acrylics). At the same time, you can begin to block in the rock formation and start to develop the planes of light and dark. Allow to dry.

### Reinforce Your Drawing

Reinforce your drawing with oil paint diluted with mineral spirits, in one of your painting's predominant colors. This keeps the pencil lines from showing through later or smudging.

### Using Alkyds and Acrylics With Oils

Alkyd is essentially an oil-based material, so there isn't any problem in using it as an underpainting for oil. However, acrylic paints are different from oils. I use acrylic to "stain" a canvas, but keep it very thin, using it as a transparent wash. I wouldn't recommend applying oil over a solid layer of acrylic paint. Remember, never apply acrylic *over* oil paint.

## 6. PAINT THE SKY

In most landscapes, the sky should be completed first, as all other planes of the painting will be in front of it. For this painting to be successful, the sky must have the feeling of glowing light. To accomplish this, the paint must be thin and the sky must be finished in one session, while the paint can be removed and blended. Before you start to paint, squeeze out all the colors you'll need for the sky—Winsor Violet, Naples Yellow, Cadmium Scarlet and a generous amount of Titanium White—and mix each with just enough Liquin to make the paint workable and easy to brush. Mix Liquin with all your colors in the following steps so the paint will dry quickly. Using Liquin in the glazes also brightens the colors. Separate some Titanium White and mix it with Winsor Violet to make the color for the top of the sky. Divide the remaining white into two parts, adding Naples Yellow and Cadmium Scarlet to produce the lighter sky tints, making one a soft orange-yellow and the other a more vibrant pink. Using a no. 7 bristle filbert, apply the sky colors in bands, starting with the rose pink at the horizon and moving up through the dusty orange to the violet. Using too much paint is better than using too little, as you will be removing paint in the blending process. Blend the edges of each band together with a bristle brush, then soften them with a no. 3 goat-hair wash brush, as demonstrated at right. The top of the sky should be a slightly darker shade of violet, so use a no. 7 filbert to pick up some Winsor Violet from your palette and mix it into the paint at the top of the sky. Blend it as well as possible with the bristle brush, then switch to the goat-hair blending brush to finish softening the blend. Try not to remove much paint near the horizon since you don't want the ground showing through there. Clean your blending brushes when they become saturated with paint and continue to work on the sky.

When you have finished blending the tones, and while the paint is still wet, add the clouds to the upper sky. The upper clouds are created by varying the amount of paint covering the ground color; no additional paint is added. Use clean no. 7 and

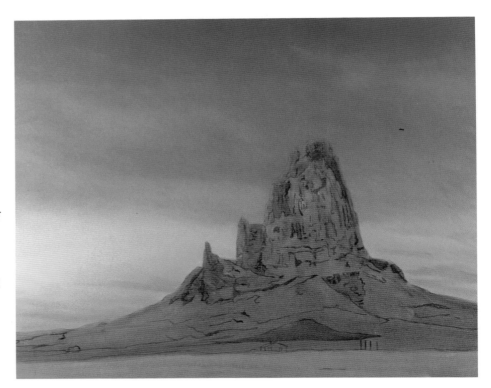

## Blending

To produce a graduated tone from light to dark, or a graduated color shift from one color to another, premix all the colors required prior to painting. Keep the colors very close in value or it will be hard to obtain a smooth transition.
(1) Paint the colors in bands across the area.
(2) Use a clean brush to zigzag along the edge of

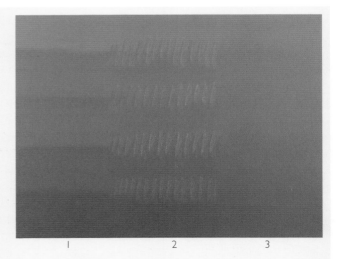

each value, moving one color into the other. (3) When all the edges are blended, "dust" a softening brush lightly over the edges until there is a smooth transition of tone. The secret to blending is to use plenty of paint, as the blending process removes paint from the canvas. Use as little medium as possible or the paint will streak instead of blend.

## Cleaning Your Brushes

Your blending brush will pick up paint as you blend, so it's best to have several on hand. If you only have one blending brush, after each blend, wipe off as much paint as you can, rinse it in mineral spirits and wash it in soap and water until clean. You can then use a hair dryer on the bristles to speed up the drying time. Blending brushes should be completely dry before being used.

no. 4 bristle filberts to remove paint, exposing the toning color where you want clouds to appear. When you're satisfied with the arrangement, soften them with the no. 3 goat-hair blending brush. Lightly paint in the clouds close to the horizon with a mixture of Winsor Violet and Titanium White on a no. 4 filbert. Don't use a lot of paint; you don't want the clouds to dominate the painting, only add to the sense of light. Again soften with the goat-hair blending brush. All edges in the sky should be kept soft so they will recede behind the rock formation. If you've covered the edges of the rock formation in the process of blending the sky, remove the paint while it is still wet.

## Hard and Soft Edges

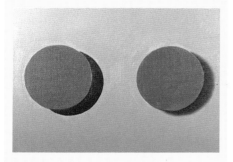

Control your edges to enhance the feeling of depth in a painting: Use soft edges on round objects and all things in the distance; use hard edges only in the foreground of a painting. In this example you can see how softening the edge of the right circle's shadow gives the illusion it is receding. To soften an edge, while the paint is still wet take a clean brush and tap it along the edge until it blurs. Part of the trick is knowing when to stop: If you oversoften an edge it becomes so fuzzy that it loses definition.

## Fixing Mistakes

To remove wet paint, dilute it with a brush dipped in linseed oil, then lift it with a soft, lint-free cloth (not a paper towel). Remove as much of the oil as possible, as it will make the canvas slippery and yellows over time. Never remove paint with mineral spirits or turpentine, as they can remove not only wet paint, but dry paint as well.

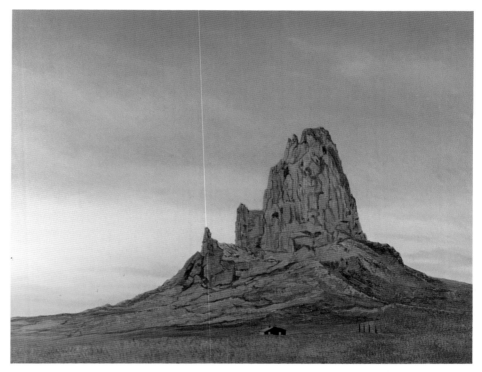

## 7. PAINT THE ROCKS AND FOREGROUND

When the sky is dry, start to work on the rock formation and the foreground. You want the rock formation to come forward, so leave the edges between the rocks and sky hard. To increase the contrast between the sky and rocks, darken the rocks with a transparent glaze of Winsor Violet and Liquin, using a no. 8 watercolor round. While this glaze is wet, add form and details using mixtures of Winsor Violet, Indian Red and Indigo, using both the no. 2 and no. 0 watercolor brushes. Build up the texture in the foreground desert by lightly tapping the side of an old watercolor brush loaded with the glaze of Winsor Violet against your canvas. Next paint in the parts of the rock catching the light with Cadmium Scarlet and Indian Red, using a no. 2 watercolor brush. Resist the temptation to add white! In later steps you will glaze over these colors to create the effect of evening light hitting the reddish rocks. Allow the painting to dry before moving on to the next step.

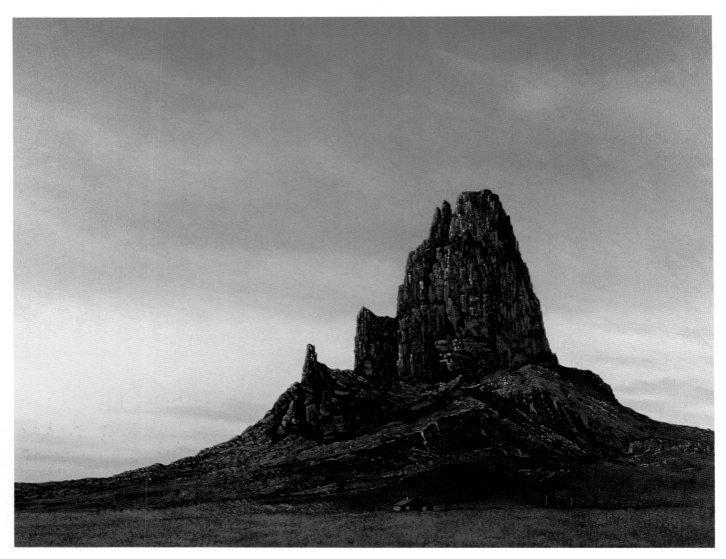

## 8. ADD DETAIL WITH GLAZES

Repeat the previous step, this time adding more details to the rocks and strengthening the areas of shadow. Take advantage of the shapes starting to emerge from the glazes to form the details of the rocks. You can see how the transparent violet changes the color of the Cadmium Scarlet to produce a totally different color. When you glaze over a dry color, the resulting color will be different than if you had mixed the colors together on the palette while they were wet. When you're finished glazing, make up a light violet using Winsor Violet, Titanium White and Liquin. Use this color to add lighter areas to the rocks in areas where the sun wouldn't reach. Then use Cadmium Scarlet to add more lights and details where the setting sun is catching the top of the rocks. These colors will be deepened even further in the next step.

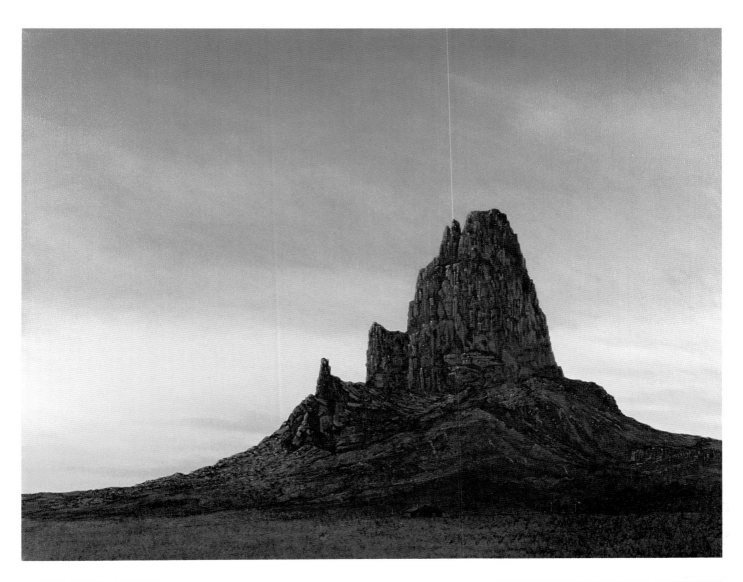

## 9. FINAL GLAZING

Continue glazing selectively, building the glazes up in some areas and leaving them thin in others to suggest details and shadows in the rocks and desert in the foreground. Mix Winsor Violet with Titanium White and use the no. 0 watercolor round to add some lights to some of the darker rocks, bringing them forward. When you glaze over this color, it will produce a deep, glowing purple. When you are satisfied with the glazing, add small spots of Cadmium Scarlet with a no. 0 watercolor brush to the areas of rock catching the light. This paint should be applied impasto so it will catch the light.

### *Impasto*

Impasto is the thick application of paint to the canvas. Use this technique only for light values so that they will catch the light. Darks should be applied thinly.

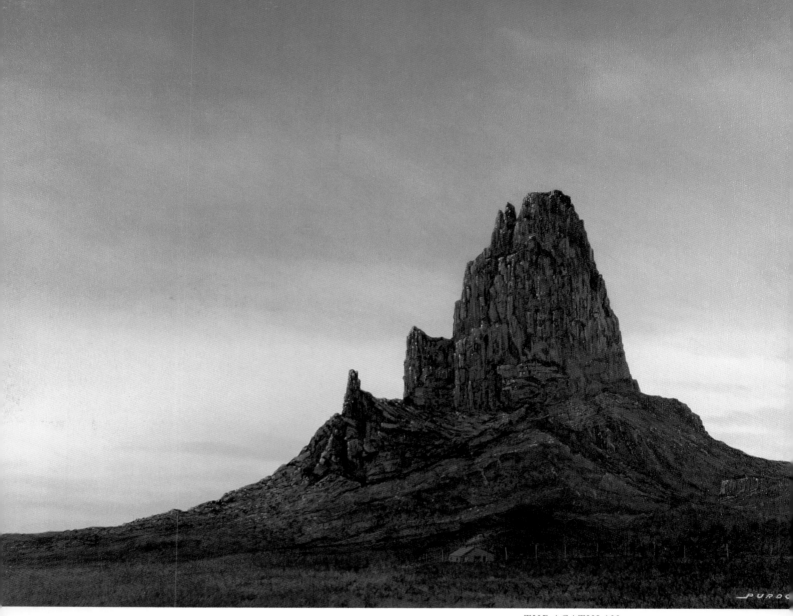

## 10. FINE-TUNING

The cabin has been left until the painting is almost finished so the values can be adjusted to the final painting. Keep the tonal range close to the background rocks so it won't jump out of the painting. Using a no. 0 and no. 2 watercolor brush, paint in the cabin using Winsor Violet, Indian Red, Indigo and Titanium White. When finished, mix a very muted orange using Naples Yellow, Cadmium Scarlet and Winsor Violet to indicate a dim light in the cabin window. Resist the temptation to use a high value for the window lights as this would detract from the light in the sky. Using glazes of Winsor Violet and Indigo, adjust any values you feel are too light. By glazing over the Winsor Violet/Titanium White mixture from the previous step, you'll create a rich, glowing violet in the rock shadows. Finally, using Cadmium Scarlet from the tube and a no. 0 watercolor round, add more paint to the highlights. When you've finished "fine-tuning" the painting, sign it—I use a no. 0 watercolor round and Titanium White thinned with Liquin.

# Waiting for Spring

## Materials Used in Finished Painting

### OIL PAINTS
- Cadmium Yellow Medium
- Cadmium Scarlet
- Cobalt Blue Deep
- Burnt Sienna
- Titanium White

### ACRYLIC PAINTS (Optional)
- Cobalt Blue

### BRUSHES
- no. 7 bristle filbert
- no. 8 bristle filbert
- no. 0 watercolor round
- no. 2 watercolor round
- no. 3 wash brush
- no. 3 Winsor & Newton series 240 goat-hair watercolor mop

### OTHER
- 12" × 16" (30.5cm × 40.6cm) stretched and prepared fine-weave canvas
- carbon or charcoal pencil
- Liquin
- mineral spirits
- palette knife

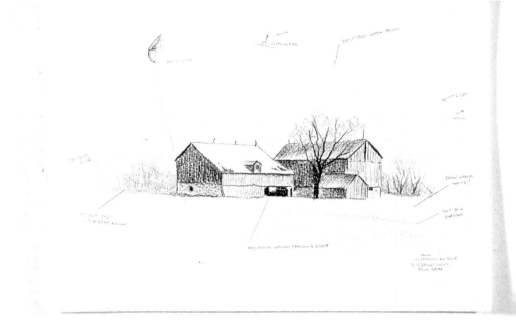

## 1. START WITH A SKETCH

I always carry a small sketchbook with me. When I saw these old barns with the light catching the farm wagon in the doorway, I stopped my car and did this quick pencil study. As it was early March and very cold, I made color and detail notes so I could plan the painting later in my studio.

# FIRST COLOR POOL

The colors for this painting are few and demonstrate the advantages of color pooling. An effective painting can be made by limiting yourself to only three colors. For doing this preliminary work, I use inexpensive canvas pads to see how the colors will look on canvas. You can use any material that accepts oil paint. I will use two color pools to produce studies for this painting.

For a more complex subject, I might do three or four color pools before deciding on the one I feel best suits the subject. For the first pool I pick Thalo Blue (Grumbacher), Cadmium Yellow Medium and Cadmium Scarlet. These are all warm colors; I'm curious to see how they will look in a painting of a cold winter subject.

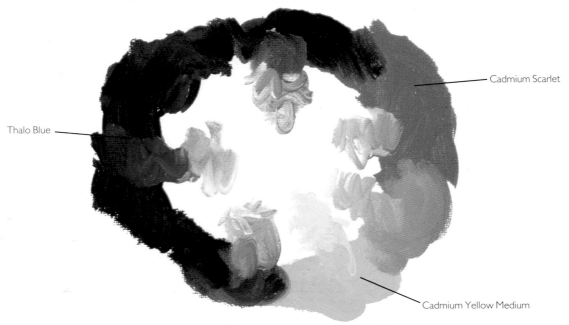

Thalo Blue

Cadmium Scarlet

Cadmium Yellow Medium

# FIRST COLOR STUDY

Do a quick sketch of the scene with a marking pen and paint a small study using the colors in the first pool. I feel that there is something missing in the sketch of the barns. I decide to move the tree line closer and to add some hills to the background to improve the composition of the scene. Use mineral spirits to dilute the paint so it dries quickly. Make no attempt to include any of the fine details. The purpose of this study is to show how the colors will work together in the painting, not to produce a finished painting. This is an experimental tool for your own use only! Let yourself run free and try new ideas.

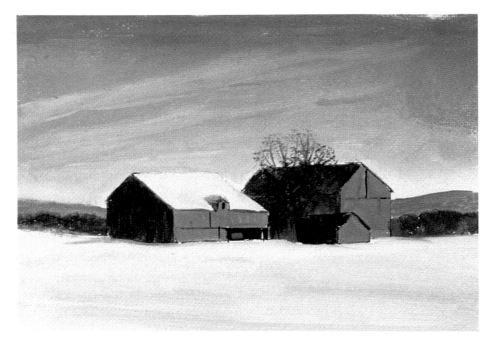

## SECOND COLOR POOL

The first study was too warm, so this color pool contains cooler colors: Burnt Sienna, Cadmium Yellow Medium and Cobalt Blue Deep (Old Holland). The Cobalt Blue Deep is not as green as the Thalo Blue and therefore cooler. The Burnt Sienna is a low-chroma orange, so when mixed with the Cobalt Blue Deep it makes a very effective dark that can be used instead of black and can also be shifted toward either blue or brown. I liked the effect of sunlight on the snow that Cadmium Yellow Medium created in the previous study, so I have decided to use it again.

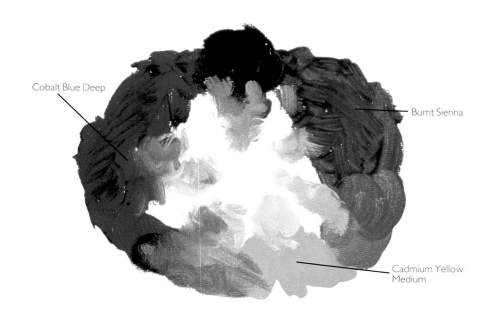

Cobalt Blue Deep

Burnt Sienna

Cadmium Yellow Medium

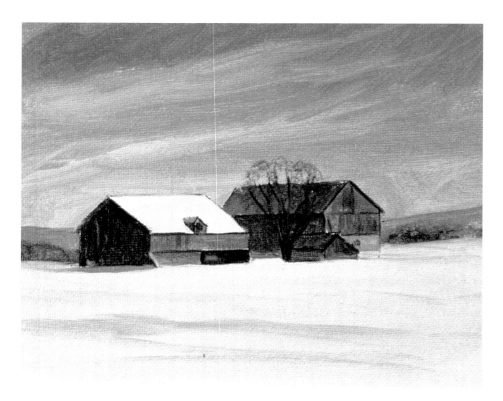

## SECOND COLOR STUDY

When I have finished the second color study I find that I like these colors more than the ones used in the first study. However, I do like the effect of the Cadmium Scarlet in the first study on the farm equipment just catching the sunlight in the barn, so I decide to use it as a local color in the final painting, but not in the color mixtures.

## 2. TRANSFER THE DRAWING

The fine-weave canvas I use for finished paintings has enough texture to keep the paint from sliding around on the canvas, but is fine enough to allow for detail work. Lightly draw in the subject on the canvas with a carbon pencil. Keep the drawing light so you can paint over it, avoiding too much detail. If there is too much information, the temptation is to color in the forms rather than freely painting the subject. When the drawing is finished, go over it with Cobalt Blue Deep oil paint diluted with mineral spirits, since this color will be predominant in the painting. The paint should be kept thin so it will dry quickly. Indicate the shadows to establish the direction of the light. This step can also be done with acrylic paint, which dries even faster. When I work in oil outdoors I carry a couple of tubes of acrylic for use in blocking in the subject. You can paint oil over acrylic but *not* acrylic over oil! Technically you shouldn't overpaint acrylic with oil. Since most canvas today is primed with an acrylic gesso, you are already overpainting acrylic and the paint is only applied as a stain, not a heavy application. If you have any doubts, you can use oil or alkyd rather than acrylic.

## 3. WASH IN COLOR

When the previous step is dry, mix the colors to be used in the painting, dilute them with mineral spirits and do a "wash-in." This wash helps prepare the canvas for the following paint and prevents the appearance of "pinholes" (white canvas showing through the finished painting). It also gives you a preview of how the colors will look on the finished painting. Because you didn't add any medium, this layer will dry very quickly. It also follows the time-proven rule of painting "fat over lean."

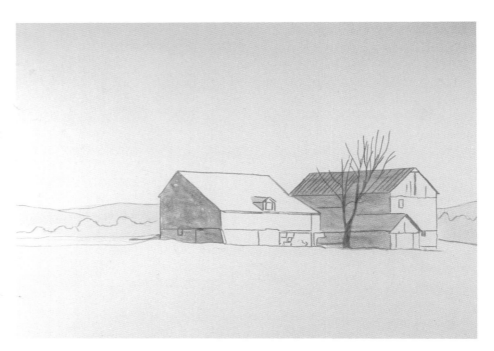

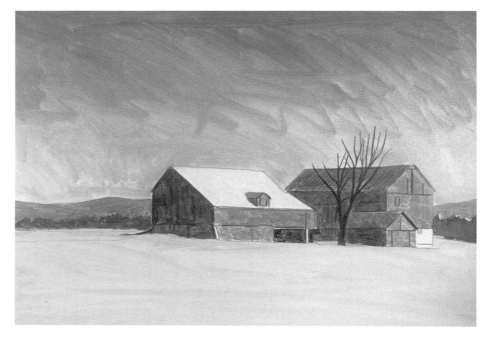

## *Fat Over Lean*

This means that each succeeding layer of paint should contain more oil (or medium) than the last. Thinning your paint with mineral spirits spreads out the oil particles, making the wash very lean. As you build the layers, you can use paint straight from the tube, which will be thicker or "fatter." Finally, you can add successive layers of glazes—the more medium you add to the paint, the more each particle of pigment is coated and the "fatter" it becomes. Oil migrates to the layers underneath and binds with them, producing a painting that's unified and resistant to cracking.

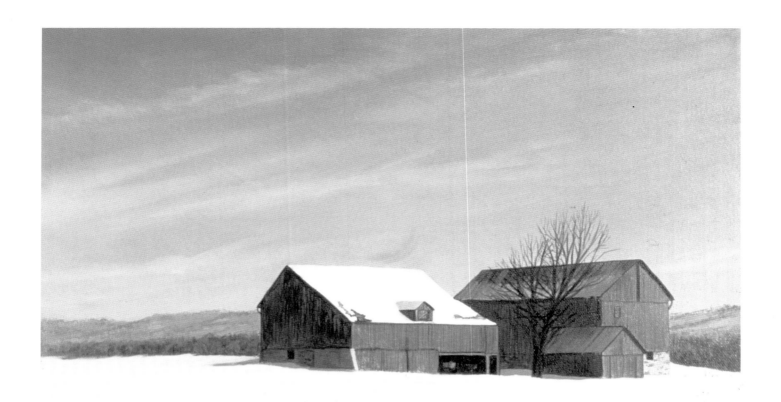

## 4. BLOCK IN BASIC VALUES

When the wash-in is dry, squeeze out your colors—Cobalt Blue Deep, Cadmium Yellow Medium, Burnt Sienna and a large quantity of Titanium White—and mix each with just enough Liquin to make the paint workable and easy to brush. Now mix up a pale yellow for the clouds and snow: Using your palette knife, move some white to one side of the palette. With the paint remaining on the knife, pick up a very small amount of Cadmium Yellow Medium and mix it with the white on the knife. Place some of this strong yellow tint on the palette and clean the knife off. Then add a small amount of this mixture to the pile of white separated previously. The resulting mixture is a pale yellow. If you add the Cadmium Yellow Medium directly to the white, it's difficult to control the amount and the yellow usually ends up dominating the mixture. Use this mixing method whenever you want to produce subtle tints from strong colors.

Next mix Titanium White and Cobalt Blue Deep for the deepest sky color. Divide this mixture in thirds, then add white to each third until you have three values of blue. Using the blending method demonstrated on page 30 and a no. 8 filbert, use these three values to create the even gradation for the blue sky.

While the sky is wet, start to paint in the clouds, using the mixture of Titanium White and Cadmium Yellow Medium you'll use later for the snow. I seldom use pure white in a painting as it tends to look too bright and chalky—reserve it for the very bright highlights. When you like the shapes of the clouds, use a no. 3 wash brush to soften the edges. You can correct areas that aren't working and repaint them if necessary. This is the great advantage of painting in oil compared to acrylic and watercolor.

Use a no. 2 watercolor round to paint the shadow side of the buildings with a dark mixture of Burnt Sienna and Cobalt Blue Deep. Add white and a little Cadmium Yellow Medium to this mixture to paint the sunlit side of the buildings one value darker than you want them to be in the finished painting; this will allow you to add detail in lighter paint later. Paint the foundations of the barns with gray mixed with a small amount of Cadmium Yellow Medium and Burnt Sienna. Paint the hills with a mixture of Cobalt Blue Deep, Burnt Sienna and white. While the sky is still wet, soften the edges of the hills where they meet the sky so they won't appear as if they were cut out of paper. Add more Cobalt Blue Deep and Burnt Sienna to this mixture to paint in the tree line. Block in the foreground snow with the mixture of Titanium White tinted with Cadmium Yellow Medium and a no. 7 bristle brush. Use some of the sky mixture to indicate the shadows on the snow. When the canvas is completely covered with oil paint mixed with medium, allow the painting to dry before adding the final details and making minor adjustments in values.

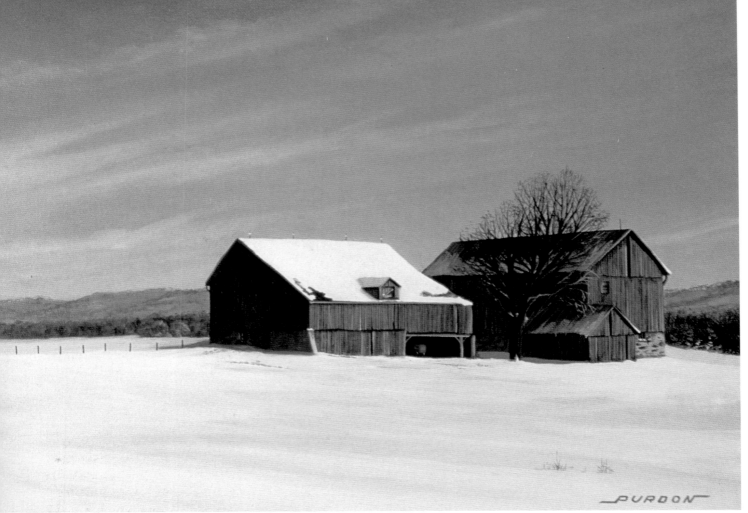

WAITING FOR SPRING
*12" × 16" (30.5cm × 40.6cm)*

## 5. FINE-TUNING

Start to refine the barn details, distant hills and tree branches with your no. 0 and no. 2 watercolor rounds and a dark-value mix of Cobalt Blue Deep and Burnt Sienna. Keeping the direction of the light in mind, repaint some areas of the trees with a second coat when the first starts to dry, giving the effect of shadows on the tree branches. When dry, add lighter branches and snow in the tree crevices. With a splayed no. 2 watercolor round, pick up Burnt Sienna, then remove most of the paint from your brush by working it back and forth on a rag or paper towel. Lightly move the brush over the edges of the branches so that only the high spots of canvas catch a small amount of color, indicating twigs catching the light—this technique is called dry-brushing. Use Burnt Sienna mixed with Liquin to paint the rusty areas on the roof of the barn. Once these dark details have set, usually in a cou-

ple of hours, start to add highlights to the barns using a lighter value of the block-in color. By painting the sunlit side of the barns at least a value darker than you want them, you are now able to add lighter values to give the effect of light catching the edges of the old boards. When I complete the side in the light, I realize the shadow side is too light; deepen it with a glaze of Cobalt Blue Deep and Burnt Sienna. When dry, start to "fine-tune" the painting by adding extra areas of color and details where they will add interest to the painting. I add impasto paint for the snow on the roof and use Cadmium Scarlet for the red wagon in the doorway so these elements will catch the light. I never use impasto paint for dark areas. While not in the original sketch, I add some fence posts to the left and a small tuft of grass peeking through the snow in the foreground.

### *Final Check— First Impression*

Let your painting dry for about a week where you won't see it, then take another look. The most important check is to walk out of the studio and look at the painting as you come back in, the way viewers will see it for the first time. This first impression must work. If there's nothing to adjust, I sign the painting and place it in storage. After it has had a few months to fully cure, apply a very thin layer of varnish to brighten the colors and protect the painting.

# Land of the Mountain and the Flood

## Materials Used in Finished Painting

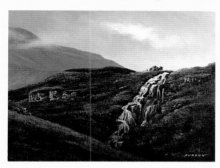

### OIL PAINTS
- Burnt Sienna
- Cadmium Yellow
- Cadmium Green
- Ultramarine Blue
- Indigo
- Winsor Violet
- Titanium White

### ACRYLIC PAINTS (Optional)
- Burnt Sienna
- Dioxazine Purple (substitute for Winsor Violet)

### BRUSHES
- no. 4 bristle filbert
- no. 7 bristle filbert
- no. 0 watercolor round
- no. 2 watercolor round
- no. 3 Winsor & Newton series 240 goat-hair wash brush
- no. 6 sable bright
- old 1-inch (2.5cm) watercolor flat (well worn and hairs splayed)
- old no. 10 watercolor round (well worn and hairs splayed)
- 2-inch (5.1cm) housepainter's brush

### OTHER
- 12" × 16" (30.5cm × 40.6cm) stretched and prepared canvas
- carbon or charcoal pencil
- Liquin

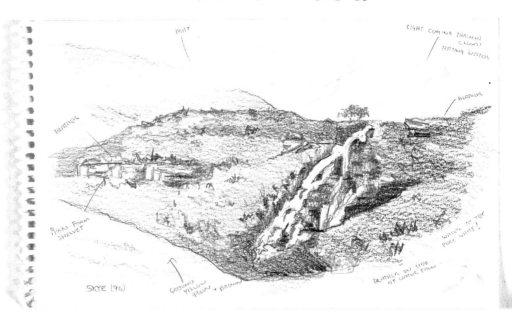

## 1. PLAN YOUR PAINTING FROM A SKETCH

I came across this waterfall in the early morning while hill-walking in the Scottish highlands. I was intrigued by the light filtering through the lifting mist and catching the foam on the water gushing out of the hillside. I did this pencil sketch very quickly on location, adding reference notes so I could do a painting of it later. As Scotland is located quite north (58° latitude), the sun is low in the sky and the light is slanting, even in the summer. Being surrounded by water, the humidity is high, softening colors and edges. I have noted on my sketch that the light was coming through the clouds from the upper right background and hitting the water, producing bright highlights. This produced a spotlight effect on the waterfall, which I will try to capture in my painting. To do so, I will use lower values in the rest of the painting, reserving the high values for the area of light. I have also noted that mist was drifting over the distant hills and the foreground moors were covered with plants and heather.

## Clear Skies Above

When transferring your sketch to canvas, never draw anything in the sky. Regardless of how pale the drawing is, it will show through the paint, especially when the paint becomes more transparent with age. If you have too much detail in the drawing, you will be reluctant to paint over it and the finished painting will lack unity and freedom, instead looking like a paint-by-number. This rule also applies to any area you wish to paint freely.

## FIRST COLOR POOL

Using my notes as a guideline, I will now start some color pools. I am going to do two color pools for this painting. For the first color pool I will use Naples Yellow Deep, Cobalt Blue Deep, Indigo, Indian Red and Winsor Green. Instead of black, I again use Winsor & Newton Indigo. I like the effects obtained by the Indigo when mixed with the yellow and red, but wonder if perhaps brighter colors would work better.

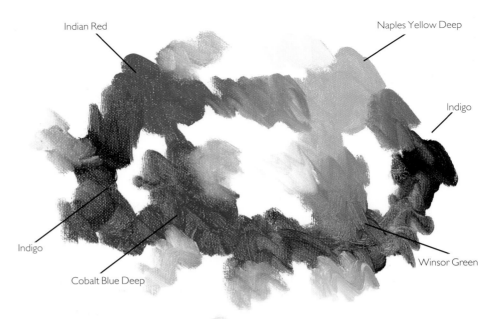

Indian Red
Naples Yellow Deep
Indigo
Indigo
Cobalt Blue Deep
Winsor Green

## SECOND COLOR POOL

I will now try a slightly different group of colors. I keep the Indigo in place of black for my darks, but substitute the Naples Yellow Deep with Cadmium Yellow, the Cobalt Blue Deep with Ultramarine Blue, the Indian Red with Burnt Sienna, and the Winsor Green with Cadmium Green. I feel this second pool comes the closest to the colors I observed on location. However, none of the colors I have selected will produce the violet needed to paint the heather I noted in my sketch, so I decide to use Winsor Violet for the purple flowers of the heather, but not to use it in any of the color mixtures.

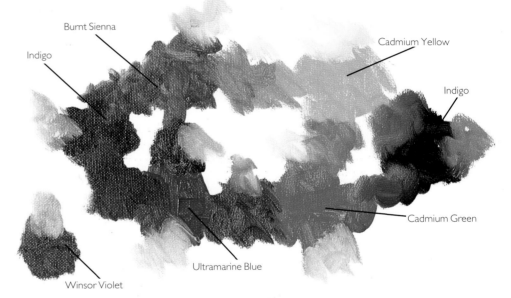

Burnt Sienna
Indigo
Cadmium Yellow
Indigo
Cadmium Green
Ultramarine Blue
Winsor Violet

## 2. TONE THE GROUND AND WASH IN DARKS

Using the 2-inch (5.1cm) house painter's brush, tone the canvas with a thin stain of Burnt Sienna. You can use oil paint diluted with mineral spirits and Liquin until it is thin enough to brush easily, or, if you wish to shorten the drying time, you can substitute acrylic paint. When dry, use a carbon pencil to lightly draw in the major shapes of the painting, using the original sketch as a guide. When you are satisfied with the drawing, go over it with Winsor Violet diluted with Liquin and mineral spirits. If you toned the canvas with acrylic, you can use Dioxazine Purple acrylic if you prefer. You can also indicate the areas of dark at this time.

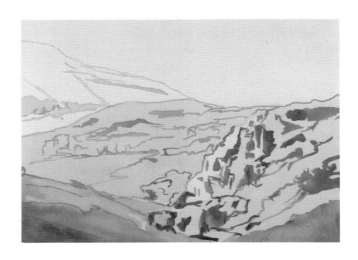

## 3. PAINT THE BACKGROUND

When the previous step is dry, start to paint the sky and background hills. The sky is painted using a mixture of Ultramarine Blue and Titanium White with small amounts of Burnt Sienna and Cadmium Yellow added, using no. 4 and no. 7 bristle filberts. Paint the background hills at the same time using a deeper value of the sky color with some Indigo added. Adding a small amount of Cadmium Green and Indigo to the hills gives the effect of details; don't show too much detail or the background will compete with the foreground. By painting the background and sky simultaneously, you can soften the edges of the hills into the sky with a no. 6 sable bright, creating the effect of mist. Next, use a no. 3 goat-hair wash brush to very lightly dust over the sky to soften the clouds and mist.

### Using Pure White

When painting atmospheric effects like clouds, mist and fog, the temptation is to use pure white. You should *never* have pure white in a painting except (and then only rarely) in the foreground. Pure white should only be used to indicate bright light.

## 4. BUILD UP THE FOREGROUND HILLS

Wait until the sky and background are dry before you proceed to this step. You now want a hard edge where the foreground hills meet the background to make the foreground advance. Place Cadmium Yellow, Cadmium Green, Ultramarine Blue and Indigo on your palette. Don't use any white at this stage; you want to keep the colors as transparent and dark as possible. Mix some Liquin and a small amount of mineral spirits into each color until it is fluid. Using a couple of old, worn watercolor brushes, apply color to the foreground by gently tapping the side and tip of the brushes on the canvas, producing small dots and dashes of transparent color. These transparent colors will darken the ground as the process is repeated, yet still allow the earlier color to

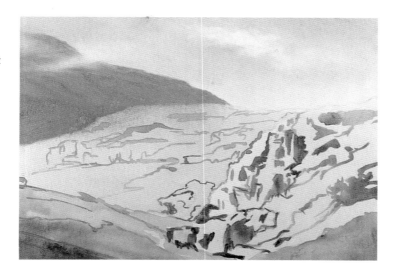

### Painting Details

When faced with a very detailed area, don't try to paint every bush or blade of grass—your painting will look overworked and too photographic. Suggesting textures and patterns but leaving the completion of details to the imagination of the viewer, makes your painting look far more realistic. It is a fine balancing act to include just the right amount of detail, but once you master it, you'll produce striking paintings.

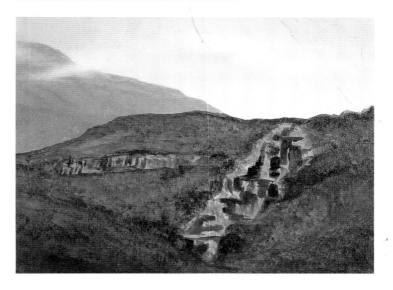

show through. Build up a varied pattern of colors, textures and values. You can refine this later to give the illusion of detail. The secret in painting something as detailed as the moor is to keep it simple. As you will see in the finished painting, it will look as if you painted every blade of grass and twig.

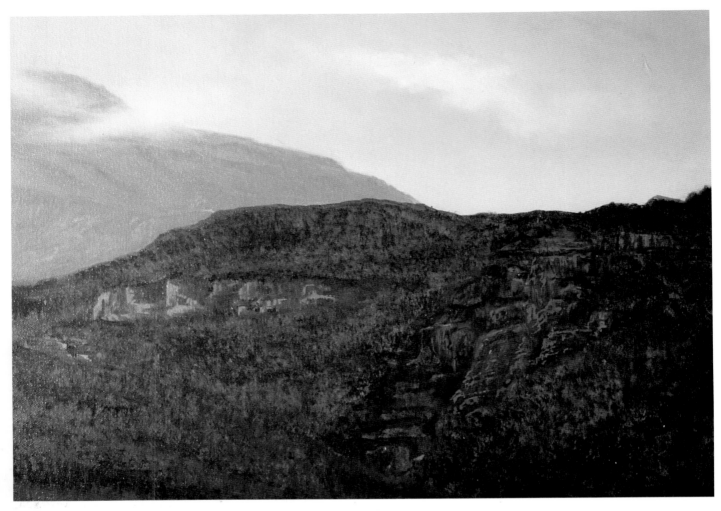

## 5. CONTINUE DEVELOPING THE FOREGROUND

Again, you must wait for the previous stage to dry before continuing. You'll now start to take advantage of the patterns formed in the previous step, developing them into areas of light and dark and introducing color. Using a no. 2 watercolor round and Ultramarine Blue and Indigo mixed with Liquin, paint over the light areas of the rocks. Using the same brush and while the paint is still wet, paint in the rocks on the waterfall and hillside with grays made from Indigo, Burnt Sienna and Ultramarine Blue. Remember to keep all values in the low ranges throughout the painting so there will be a large jump in values when you add the white of the water.

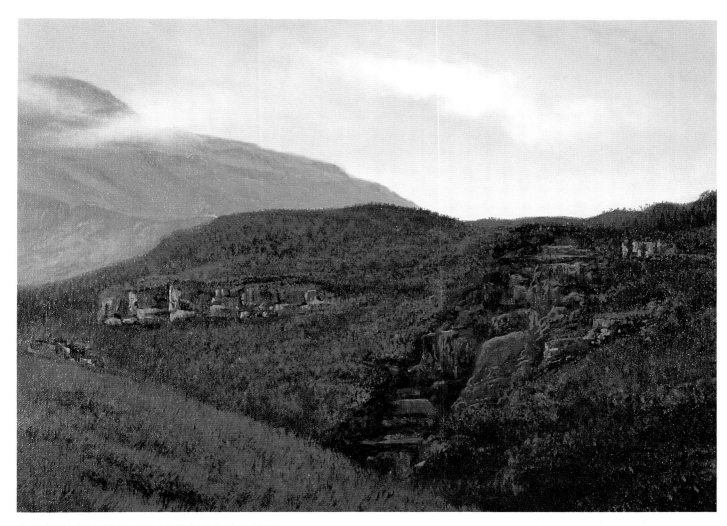

## 6. DETAIL THE GRASS AND ROCKS

Now mix the lighter colors required for the moor using Cadmium Yellow, Cadmium Green, Burnt Sienna, Ultramarine Blue and Titanium White. You can make excellent low-chroma greens with the Ultramarine Blue and Cadmium Yellow, reserving Cadmium Green for the lightest areas. Using your splayed brushes and a no. 0 watercolor round, start to add detail to the foreground. If an area becomes too bright, you can always put a transparent layer of Ultramarine Blue or Indigo over it when it's dry to reduce its intensity. Also start to refine the details of the rocks and hillside.

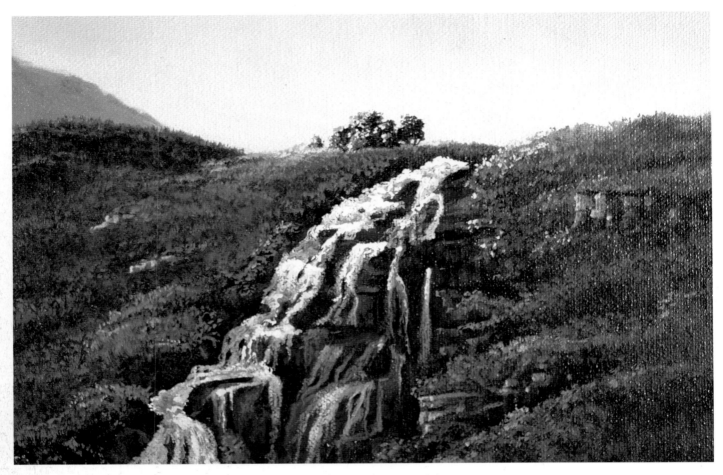

## 7. FINISH THE HILLSIDE AND START THE WATERFALL

Using Cadmium Yellow, Cadmium Green, Ultramarine Blue and Burnt Sienna, build the lights on the hillside rocks and indicate the leaves of individual plants using a no. 0 watercolor round. Don't try to paint the complete plant; just indicate the odd leaf catching the light and the eye will complete the rest. Remember not to make these lights too high in value as you don't want them to overpower the light on the waterfall. Now paint the larger heather flowers on the sides of the waterfall and scatter smaller clusters throughout the hillside rocks using Winsor Violet and Titanium White.

Using a no. 0 watercolor round and Titanium White slightly lowered in value with the addition of Ultramarine Blue and In-digo, paint in the water tumbling down the rocks. Keep the paint stiff (impasto) and use only the tip of the brush to apply it. Don't brush it out or blend it; you want this paint to catch the light. Use only one value. When this is dry, you will reduce the value of the water using transparent glazes of Ultramarine Blue and Indigo, but at this stage you should be more concerned with the pattern of the water and how it flows over the rocks. Value adjustments can be done later. When the water is completed, you must allow it to dry completely before going on to the next step. Because this paint is thick and doesn't contain as much Liquin as previous steps, it will take longer to dry.

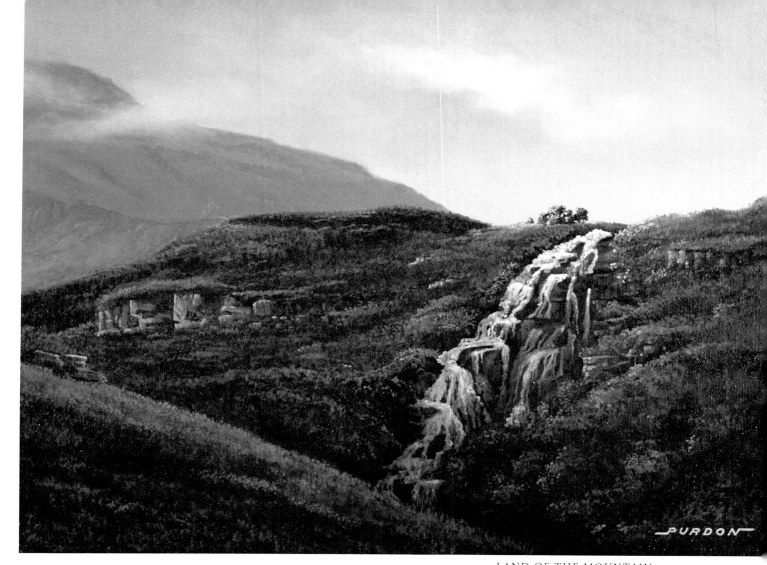

## 8. FINE-TUNING

When the water is dry, use a no. 2 watercolor round to paint a very thin glaze of Ultramarine Blue and Indigo mixed with Liquin over the waterfall to deepen its value as it tumbles into the gorge. You can vary the glaze to lighten some areas of the water and deepen others, producing the effect of light and shade on the water. While this glaze is drying, use transparent glazes to adjust any other values or colors needed to pull the painting together. For instance, you can add a glaze of Burnt Sienna mixed with Liquin to the grass in the foreground to warm it up. Using glazes of Ultramarine Blue and Indigo, you can deepen the foliage at the bottom of the waterfall. The advantage of transparent glazes is that they will still allow the previous painting to show through, al-

tering only the color and value. Using a no. 0 watercolor round, mix some Winsor Violet with white and add more purple heather on the rocks and the edge of the stream, this time leaving the paint impasto to catch the light. Also use the Cadmium Green to show leaves catching the light. Finally, add the lights to the water with a no. 0 watercolor brush and pure Titanium White mixed with Liquin. Keep the paint impasto so it will catch the light. This is one of the few times you would use white straight from the tube without decreasing its value. See the sidebar on page 60 for a trick to create even brighter highlights on water. Sign the painting and allow it to dry a few months before varnishing it.

LAND OF THE MOUNTAIN
AND THE FLOOD
*12" × 16" (30.5cm × 40.6cm)*
*Private collection, Canada*

# Red Rocks of Sedona

## Materials Used in Finished Painting

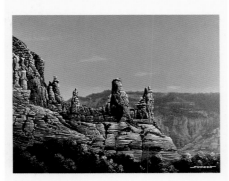

### OIL PAINTS

- Cadmium Yellow Medium
- Cadmium Scarlet
- Ultramarine Blue
- Grumbacher Thalo Blue
- Winsor Violet
- Burnt Sienna
- Titanium White
- Indigo

### ACRYLIC PAINTS (Optional)

- Burnt Sienna
- Dioxazine Purple (substitute for Winsor Violet)

### BRUSHES

- no. 7 bristle filbert
- no. 10 bristle filbert
- no. 8 bristle round
- no. 0 watercolor round
- no. 2 watercolor round
- no. 3 Winsor & Newton goat-hair watercolor mop

### OTHER

- 16″ × 20″ (40.6cm × 50.8cm) stretched and prepared fine-weave canvas
- carbon or charcoal pencil
- Liquin
- mineral spirits
- palette knife
- lint-free rag

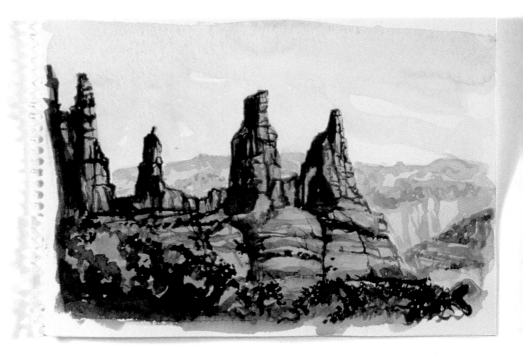

## 1. START WITH A SKETCH

This painting of the Arizona desert is a totally different landscape than the previous demonstration in terms of features, lighting and temperature. I'm working from a watercolor sketch I did on location in about twenty minutes. The advantage of a sketch over a photo is that the sketch shows an accurate relationship of light to dark; values are distorted by photography. Unless you have a sketch to refer to, your values will be incorrect in the painting. I also took photographs of the area and will use these for drawing reference, but not for color and value. The colors I used on-site will provide a starting point for my choice of colors to pool.

## 2. EXPERIMENT WITH A COLOR POOL

Because you want to convey a feeling of the warmth of the desert, limit your color pool mainly to warmer colors, based on the colors that dominate the scene. In the watercolor sketch I used Burnt Sienna, Ultramarine Blue and Gamboge. Gamboge is only a watercolor pigment, so use Cadmium Yellow Medium in its place. I also want the oil to be brighter than the watercolor, so I will replace the Burnt Sienna with Cadmium Scarlet. I add Grumbacher Thalo Blue—which I'll only use in the sky to increase the warmth of the Ultramarine Blue—Winsor Violet for the shadows on the rock formations and Indigo for the darks in the background trees. While I normally limit my pool to four colors, I have stretched this one to six. I tone a piece of scrap canvas with Burnt Sienna to test my color selections. I like the effects of the colors on the ground and also how they work with each other, so I decide on these colors for the painting.

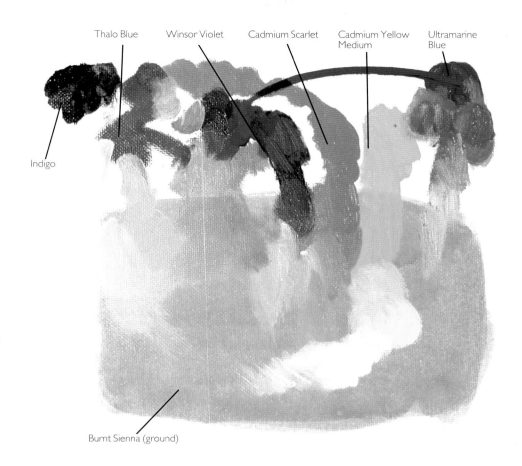

Thalo Blue  Winsor Violet  Cadmium Scarlet  Cadmium Yellow Medium  Ultramarine Blue

Indigo

Burnt Sienna (ground)

## 3. TONE THE CANVAS AND BLOCK IN THE DRAWING

I'd like the red-brown color of the rocks to influence the painting, so I tone the canvas with Burnt Sienna oil mixed with mineral spirits and Liquin, or thinned Burnt Sienna acrylic. Rather than making the paint liquid, apply it more thickly and remove the surplus with a rag until you reach the required tone. The rag must be lint-free or you will get pieces of lint mixed into your paint; for the same reason, don't use a paper towel. Old nylon stockings, pantyhose or slips are ideal for removing color as they will not leave lint. When the toned canvas is dry, transfer your drawing with carbon pencil, then block in the drawing and shadows with Winsor Violet oil; if you toned the canvas with acrylic you can use Dioxazine Purple acrylic if you prefer.

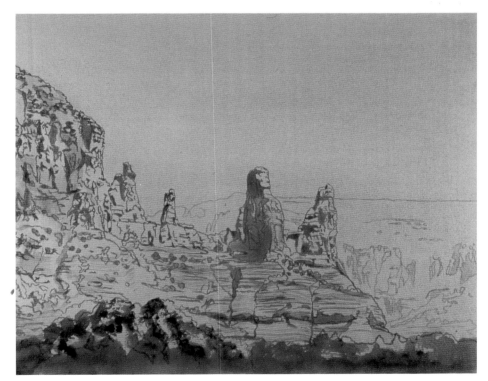

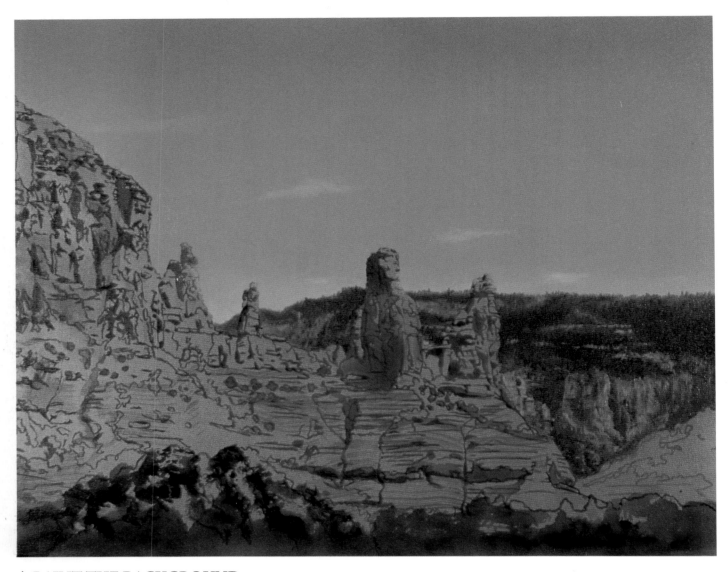

## 4. PAINT THE BACKGROUND

Because you want the toned ground to influence the final painting, don't do any underpainting but start with full-bodied color. For the sky, make a mixture of Ultramarine Blue, Thalo Blue and Titanium White. Mixing three values, paint these in bands, then blend the transitions with a softening brush. In areas where you plan to paint clouds, remove some of the sky color with a dry brush, exposing the ground. Add the clouds with a small amount of Cadmium Yellow Medium mixed with Titanium White, using a softening brush to diffuse the edges. While the sky is still wet, paint in the distant rock forma-

tions using three midrange values: a green made from Cadmium Yellow Medium and Ultramarine Blue, the green with the addition of Cadmium Scarlet and white for the rocks, and Ultramarine Blue and Cadmium Scarlet plus white for the darks. Help the background recede by keeping the details and edges soft, the values close together and the colors cool. It's critical that this step be done while the sky is still wet as you want to soften the edges where the hills and sky meet to increase the feeling of depth. When satisfied, allow the painting to dry.

### Soften Edges While the Paint is Wet

Once dry, the only way to soften edges is to repaint everything again, so it has to be right the first time!

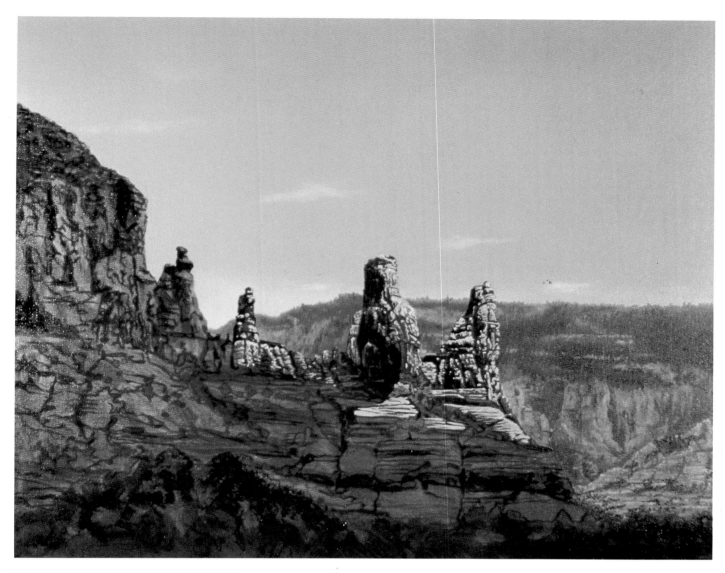

## 5. PAINT THE SUNLIT ROCKS

Increase the value of the darks by blocking in the shadows and details with another layer of Winsor Violet. Also block in the trees in the foreground bottom of the painting. Darken the Burnt Sienna ground with a glaze of Ultramarine Blue. This will give you a middle tone so you can work both darker and lighter to model the rocks. Now start to paint the details of the rocks using a mixture of Cadmium Yellow Medium, Cadmium Scarlet, Winsor Violet and white. Only block in where the rocks are being hit by the sun. Keep the values a bit lower than you want for the final painting so you'll be able to introduce the lights on them with impasto paint later on. Even though the finished painting will have more detail, don't be too concerned with the fine points at this stage.

### Don't Let Details Distract You

The secret to painting anything realistically is not to get caught up in the details at the earlier stages. You must build a firm foundation of masses and planes prior to painting the details.

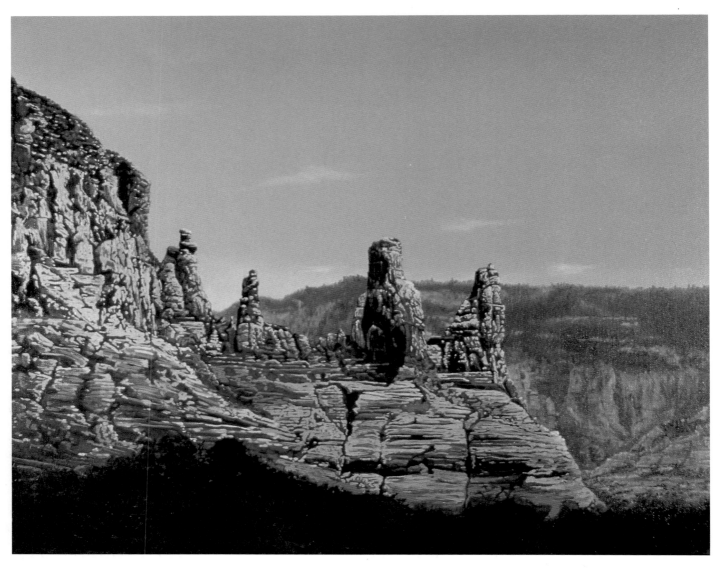

## 6. CONTINUE PAINTING THE ROCKS

I like the effect of light on the rocks I've completed, so I continue to work across the painting, using the same colors but slightly lowering the values as they approach the edge of the painting.

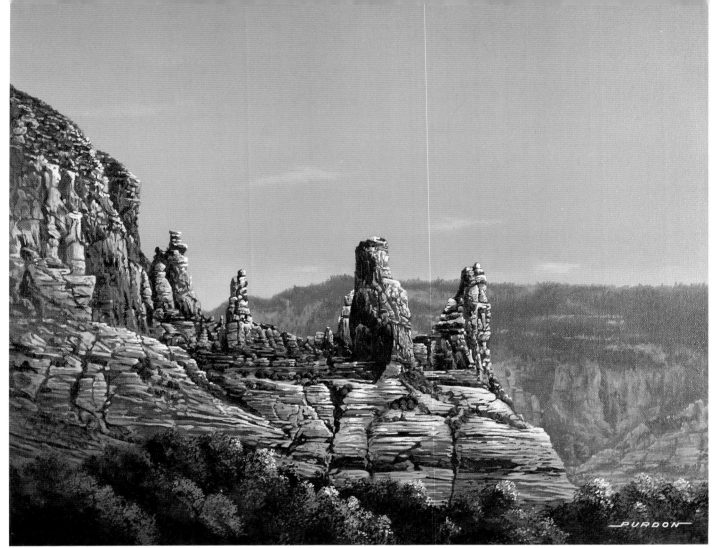

RED ROCKS OF SEDONA
*16" × 20" (40.6cm × 50.8cm)*

## 7. FINE-TUNING

Once you've finished blocking in the lights, allow the painting to dry. Now do more modeling on the rock formations using a glaze of Winsor Violet and Cadmium Scarlet thinned with Liquin. This tends to set quickly, so even though it may not be completely dry, it can be worked over with opaque paint to produce details. To get a darker glaze add Ultramarine Blue, keeping it fluid enough that you can use a small brush to draw in details of the cracks and crevices in the rock. The trick is to keep the mixture transparent enough that the previous layers shine through. When you're happy with the effects, block in the scrub brush on the sides of the butte with a mixture of Winsor Violet, Cadmium Yellow Medium and Ultramarine Blue. Let this dry before finishing the rocks and adding the trees.

To complete the painting, add the fine details to the rocks and trees. You won't be changing the overall appearance of the painting, just moving parts forward with lighter and warmer highlights and pushing other areas back by using lower values and cooler colors. In the light areas on the buttes, add lighter values with impasto paint to produce the effect of the light catching the rocks. In the shadow areas, put in a few color details, controlling the values so they don't appear to jump out. This will keep these large areas of dark from looking like black holes in the painting. Remember, however, that the areas of shadow are caused by an absence of light so it's impossible to see the details or colors in shadow that exist in light. When doing the rock details, make use of the patterns formed by the earlier applications of paint. Don't try to draw each rock—instead, build the forms by using the contrast of lights, darks and midtones occurring in the painting to indicate the structure of the rocks. In fact, when viewed up close, the forms of the rocks actually become just a pattern of strokes and dots of paint. I call this method of painting *artists' shorthand*. Leave the detailing of the trees until last for two reasons: so they can be painted in front of the rocks and so you can adjust both the values and colors so the trees will move forward in the painting. Make several values of green using mixtures of Ultramarine Blue, Cadmium Yellow Medium and white. For the darks of the trees use a mixture of Indigo, Winsor Violet and Ultramarine Blue. When you've finished the trees, darken any shadow areas that look too light with a glaze of Indigo and Winsor Violet. Now take a last look at the painting to see if there's anything that isn't working or if there are values that need to be adjusted. If not, sign the painting and put it away to dry.

# Bounty Hunter

## Materials Used in Finished Painting

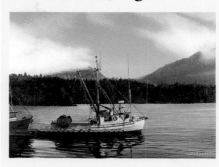

### OIL PAINTS
- Cadmium Scarlet
- Old Holland Naples Yellow Extra Deep
- Grumbacher Thalo Blue
- Ultramarine Blue
- Titanium White
- Permanent Rose
- Winsor Violet
- Indigo
- Black

### ACRYLIC PAINTS (Optional)
- Permanent Rose
- Ivory Black

### BRUSHES
- no. 8 bristle filbert
- no. 12 bristle filbert
- ¼-inch (0.6cm) acrylic flat
- no. 0 watercolor round
- no. 2 watercolor round
- no. 3 Winsor & Newton series 240 goat-hair wash brush or badger fan blender
- 2-inch (5.1cm) housepainter's brush

### OTHER
- 18" × 24" (45.7cm × 61cm) stretched and prepared fine-weave canvas
- carbon or charcoal pencil
- Liquin
- mahlstick

*Sky and water pool*

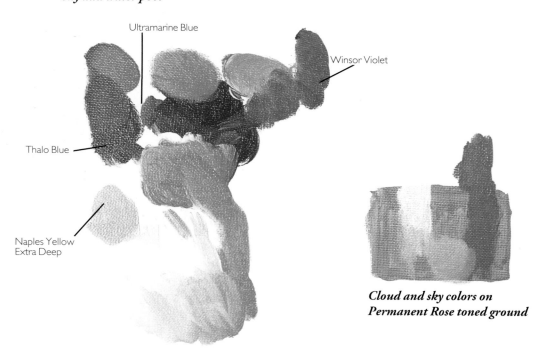

Ultramarine Blue

Winsor Violet

Thalo Blue

Naples Yellow Extra Deep

*Cloud and sky colors on Permanent Rose toned ground*

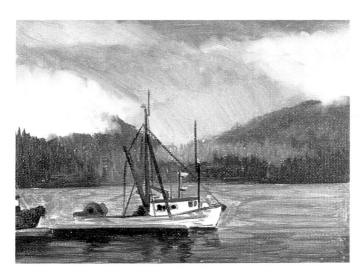

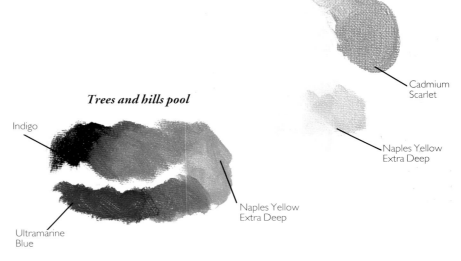

**Cloud and boat pool**

Ultramarine Blue

Cadmium Scarlet

Naples Yellow Extra Deep

**Trees and hills pool**

Indigo

Ultramarine Blue

Naples Yellow Extra Deep

## 1. COMBINE THE SKETCH AND COLOR POOLS

For the previous demonstrations I have done the color pools separately and then painted the color study on a separate piece of canvas. Once you feel confident working with the color pools, you can do both the pools and the color rough on the same piece of canvas—this is the way I normally work as it keeps everything in one place. First draw a quick sketch with a marking pen and then pool the colors around the sketch. Because I want to use a toned ground of Permanent Rose, I test the colors for the sky on a section painted with the Permanent Rose ground to see how they will look. Once you decide on the colors, do the color study for the painting. As this is a very complex subject, I have selected six colors for this painting: Cadmium Scarlet, Naples Yellow Extra Deep, Ultramarine Blue, Thalo Blue, Indigo and Winsor Violet. We'll use the Thalo Blue to warm up the sky and also for the trim details on the boat, but not in any other area of the painting. The Indigo will be used instead of Ivory Black to produce the darks.

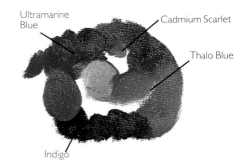

**Dark pool**

Ultramarine Blue

Cadmium Scarlet

Thalo Blue

Indigo

## 2. TONE THE CANVAS AND TRANSFER THE SKETCH

Tone the canvas with Permanent Rose oil paint mixed with Liquin and mineral spirits, or use thinned acrylic paint. This is a bright color and will influence the blues of the sky and water. When dry, transfer the drawing with carbon pencil. Go over the shadow shapes with thinned black paint, either oil or acrylic.

## Don't Paint Pure White Clouds

Many beginners make the mistake of using pure white for clouds. Clouds are influenced by the rule of aerial perspective, which states that objects in the distance are always lower in value and chroma than the same objects in the foreground. Therefore, clouds should always be reduced in value. This is one of the secrets for producing depth in a painting.

## 3. BLOCK IN THE SKY AND CLOUDS

Premix all the colors for the sky and clouds, making three values of blue. Increase the warmth of the lightest value that will be used in the lower part of the sky by adding Thalo Blue. The white for the clouds is a mixture of Naples Yellow Extra Deep, Cadmium Scarlet and the sky color. Block in the sky, leaving the areas for the clouds open so the ground color will show through. When you're satisfied with the patterns left for the clouds, paint them in. The clouds aren't pure white, but Titanium White with a small amount of Cadmium Scarlet, Naples Yellow Extra Deep and the blue of the sky mixed in. I haven't done any blending at this point to show how the sky looks prior to softening and blending; however, the blending should be done while the paint is still wet.

## 4. BLEND THE SKY AND PAINT THE DISTANT HILLS

Using a large, soft brush, soften the sky into the edges of the clouds. Next, mix the colors for the hills. Naples Yellow Extra Deep with Ultramarine Blue and Indigo gives you a good range of greens. While the sky is still wet, use a small watercolor brush to draw the trees of the distant hills into the sky; since the paint is still wet you can soften the edges. These hills are closer than those in the previous demonstrations, so keep the edges harder. Don't paint trees into the areas where the fog will appear. Paint the fog with the same color used for the clouds, blending the edges into the trees and sky. If you make a mistake, use the technique outlined in the sidebar on page 31 to remove the paint. Don't paint the shoreline until this step is dry as you want hard edges where the trees overlap the background.

## 5. PAINT THE SHORE AND WASH IN THE WATER

When the previous step is dry, paint in a thin mixture of Indigo mixed with Liquin over the distant shore. While this is wet, paint in the pine trees using greens made from mixtures of Ultramarine Blue, Indigo and Naples Yellow Extra Deep. Use Naples Yellow Extra Deep to create the effect of sunlight catching the tops of the trees. Don't try to paint each tree on the shore; just indicate the pattern, highlighting selected trees. Keep the background simple so it won't compete with the foreground. Next, using Ultramarine Blue mixed with Titanium White and Liquin, wash in the water. Use a dry brush to remove some of the color so the ground can still be seen.

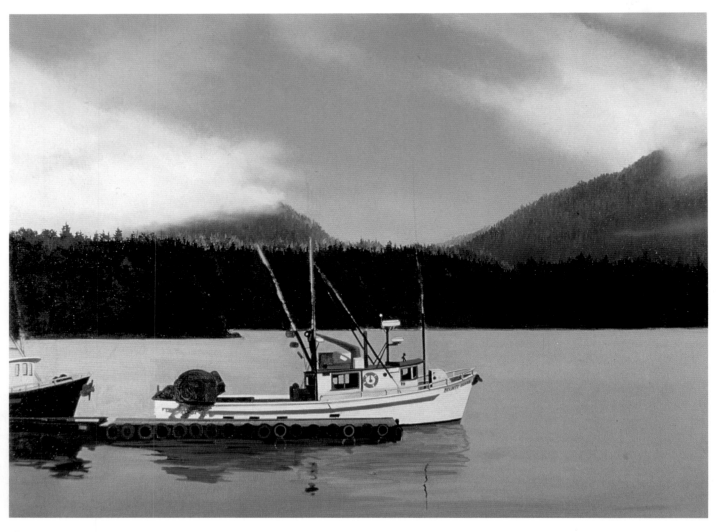

## 6. PAINT THE BOATS AND DOCK

Now it's time to paint the boats. This part of the painting will take as much, if not more, time than all the other steps combined! Use the mahlstick (illustrated in chapter one) to paint in the fine details. Paint the white of the central boat using Titanium White with a little Naples Yellow Extra Deep added to decrease its value and warm it slightly. Add a small amount of Indigo to this mixture and paint the boat on the left of the painting. Using slightly lower values for this boat will keep it from becoming a primary focus at the edge of the painting. Mix a warm brown using Cadmium Scarlet, Indigo and Naples Yellow Extra Deep and use this for the net reel at the stern. Paint in the windows and dock using mixtures of Indigo and the warm brown. For the stripe on the side use Thalo Blue and Titanium White. Add Liquin to this mixture and use a small watercolor brush to paint the name of the boat. Using mixtures of Indigo and Titanium White, block in the areas of dark on the boats and dock. Don't paint the masts until the water is finished to avoid having to paint around them. At the same time, paint in the local colors of the second boat.

### Painting Boats

Boats are fun to paint, but the drawing must be accurate and the details correct. Nautical art is a whole field unto itself, with a wide following of boat owners and boat lovers who will let you know if you make any errors. To produce an effective painting you must know the subject. Take reference photos and make detailed sketches of boats whenever possible.

## 7. FINISH THE WATER

Mix the colors for the water using Ultramarine Blue, Indigo and Titanium White, then block in the waves and ripples with a flat brush. Use glazes of Indigo for the darks. Use some of the cloud color for the lighter tones and reflections.

## 8. FINE-TUNING

When the water is finished, refine the details of the boats. For the detail work on the boats use a small round watercolor brush (no. 2 or no. 3). Keep the paint fluid enough that it flows easily but not thin enough that it won't cover. Use the small brush and mahlstick to paint in the local color of the masts with mixtures of Indigo and warm brown. While still wet, use a lighter tone to indicate the highlights. Remember that the masts are cylinders and must be painted as such. Add more details and refine the edges of the boat. As this is a working boat, it is stained with rust. None of the colors in the pool will give you the

rich brown of the rust, so use a transparent glaze of Burnt Sienna mixed with Liquin. To add texture, blot the rust with your finger. Allow the painting to dry before working on the rigging; that way if you make a mistake you can correct it without having to repaint anything. Mix Indigo and Titanium White in several values and thin it with mineral spirits and Liquin so that it flows easily, then use a mahlstick to paint the rigging. Add details and highlights where required on the boat. Complete the painting by adding impasto white paint on the lighter planes of the boat and highlights on the water. Then sign the painting!

### Highlight Trick

To create impasto highlights that really catch the light, put out some Titanium White or Flake White and mix a small amount of Liquin with it. Leave this paint on your palette overnight, allowing it to thicken and stiffen. Using a small, round watercolor brush, pick up some paint and place it on top of the highlights in the foreground. This thick impasto white will give the effect of light sparkling on water.

BOUNTY HUNTER
*18" × 24" (45.7cm × 61cm)*
*Private collection*

## How Long Does All This Take?

A question I am often asked is how long it takes to do a painting. This is a hard question to answer as each painting is different. I once heard an artist answer, "All my life." Painting is a process of constant learning; every painting you complete is another step in a long journey. But just between you and me, this painting took over thirty hours from start to finish!

# 3 *The Alkyd Advantage*

Alkyd paint has a brilliance and transparency that surpasses traditional oil paint, and with its quick drying time, you can apply two or three glazes of glowing color in one painting session.

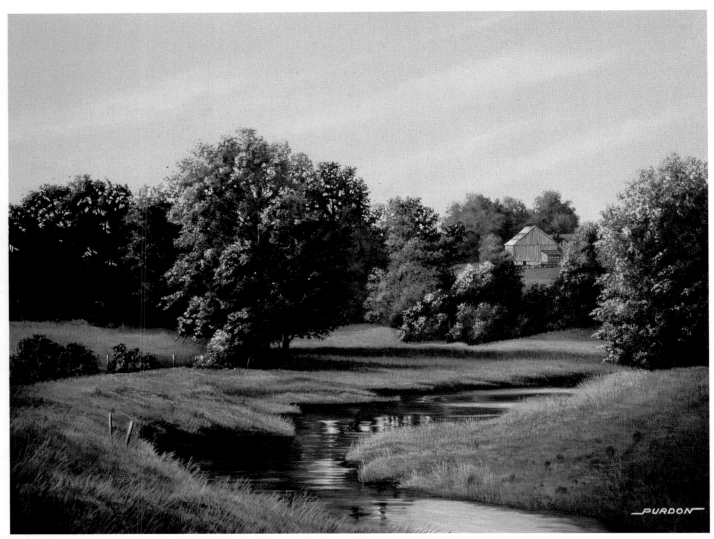

LAZY RIVER FARM
*oil on canvas, 22" × 28" (55.9cm × 71.1cm)*
*Private collection*

# Understanding Alkyds

When many artists see the word *alkyd* (pronounced Al-Kid) they assume it's a type of acrylic. However, alkyd is *not* an acrylic, but is more akin to oil paint. The pigments used in alkyds and oils are the same; only the binding agent is different. Oil colors are ground in vegetable oils—usually linseed or safflower or mixtures of both—while alkyds are ground in an oil-modified resin. (Winsor & Newton adds a small amount of linseed oil to their alkyds to help soften the paint and improve its brushability.) The alkyd resins are derived from glycerol and phthalic anhydride; as these resins are designed specifically to be binding agents for paint, they are superior to natural resins. Alkyd resins are quick drying, nonyellowing and very adhesive. An additional advantage is that all colors dry at the same rate, even colors noted for slow drying in oils, like Alizarin Crimson.

## LIQUIN

Liquin, the painting medium I've been recommending and using in the earlier chapters, is an alkyd medium. If you've been using it, you've been painting partially with alkyd already. Alkyd paint dries even faster than oil paint mixed with Liquin. It was my experience with Liquin that encouraged me to try alkyds and I have never regretted it!

## USING OILS WITH ALKYDS

Unfortunately, the number of alkyd colors available isn't as large as the range of oil colors: Winsor & Newton's oil color list has over one hundred colors, while their Griffin alkyds have about forty. However, most of the popular colors are in that range, and since oils and alkyds are compatible, if you have any favorite oil colors that aren't available in alkyd, you can simply use the oils with your alkyd palette. But remember, when you introduce oils to an alkyd painting, you will slow down the drying rate of the alkyds in relation to the amount of oil paint you add. This doesn't have to be a disadvantage: When working on a large area of a painting such as the sky or water, using a mixture of oil and alkyds will allow the paint to stay workable longer. When I work in the studio I use alkyds along with traditional oils and Liquin so that I have complete control over the drying time of my paintings. As paintings come closer to completion, I find that I use alkyds not only for adjusting areas with glazes, but also for details and impasto highlights. The rapid drying time means I can work the next day without having to worry about smudging wet paint. Since I use Liquin with my oil paint in the earlier stages, when I switch to pure alkyds to finish the painting I am still keeping with the rule of "fat over lean."

## SPEED UP THE WORKING PROCESS

Alkyds open up many possibilities, allowing you to work in multiple glazes and scumbles without having to wait days for them to dry. A glaze of alkyd mixed with Liquin will be dry enough in an hour to allow you to paint on top of it without disturbing the glaze. Paintings that are executed completely in alkyds can be varnished safely in four to six weeks, depending on the thickness of the paint. When you use linseed oil with Liquin it will increase the drying time. If I had used a traditional oil/turpentine medium in the painting of the Agathlan in chapter two, the painting would have taken weeks to dry. By adding Liquin, I reduced the working time to less than a week. If I had used alkyd paint with the Liquin instead of oils, I would have been able to work even faster. I now use alkyds exclusively when working on location as they dry even quicker outside and allow me to overpaint areas and complete a painting in one session. The painting dries overnight and can be safely packed the next morning. In the following demonstrations I will show you how alkyds allow you to complete paintings using glazes and direct painting without waiting days for the painting to dry. You also gain the added advantage of the brilliance of alkyds when they are used for glazing.

## *Fat Over Lean*

The time-tested rule of painting fat over lean should still be practiced with alkyds.

## *Preventing Plugged Tubes*

One of the problems with alkyds is that once opened, the paint can dry in the neck of the tube, forming a plug. To avoid this problem, I always dip the threads of the tube in linseed oil before replacing the cap. I find this prevents the paint drying and also makes the tube easier to open. If a plug of dry paint does form, a bent paperclip removes it easily.

## *Cleaning Up*

Because alkyds dry so quickly and cannot be removed when dry, you *must* clean your palette and brushes as soon as you are finished working.

# Glazing With Alkyds

An old term for a glaze is "veil," which I think describes the process better. Like a veil, this application of paint allows you to see through it, but also alters the underlying image. It was through the use of glazes that the Dutch Masters achieved the depth and brilliance of color they were famous for. The alkyd mediums come close to duplicating the natural resin mediums used by Dutch Masters Jan van Eyck and Albrecht Dürer.

The practice of glazing lost favor in the late nineteenth century, a period where artists worked *plein air* and *alla prima*—the intent was to paint the scene quickly on location rather than in the studio. Traditional glazing methods were often forgotten. Today, what most artists call a glaze—mixing paint with a glazing medium until it is the proper translucency, then brushing it over an area—is really closer to a watercolor wash. A true glaze is painted over an area and then carefully removed until the desired effect is achieved. While the "watercolor wash" method works to some degree, by adding a lot of medium to the paint you dilute it so much it tends to "swim" in medium and is difficult to control. If you use less medium and remove the color until it is as transparent as you wish, it will produce a deeper and more brilliant glaze. When

applying glazes to small areas, this is hard to do, so I use a more fluid glaze, but where possible, I prefer the true glazing method.

One of the traditional glazing mediums involves the use of Damar varnish. The problem with this medium is that Damar varnish is also usually used for the final varnish on the painting. If, after many years, the final varnish is removed to clean the painting, the surface glazes may be dissolved also. Alkyd resins are insoluble in most of the common solvents used in cleaning, so they will not be damaged during cleaning.

Glazes can be used throughout the painting process to alter the value and color of selected areas. If you use a transparent glaze you can alter the color without losing detail. Make sure the preceding layer is totally dry before applying more paint; otherwise the glaze will dissolve the paint. One word of caution: Many beginning artists have a tendency to overuse glazes at first. Glazing should be used to complement other painting methods, not to replace them.

## MAKING GLAZE CHARTS

If you haven't worked with glazes before, the first thing you should do is to make a chart similar to the one shown at left below. Paint strips of the colors you use in your

### Transparent Colors

Alkyd transparent colors are brighter than the same colors in oil and add depth and clarity to glazes. In Winsor & Newton's Griffin alkyd range, the following colors are *very* transparent: Dioxazine Purple, French Ultramarine, London Red, London Yellow, Rose Madder, Alizarin Crimson, Phthalo Green, Phthalo Blue and Sap Green. The following colors aren't totally transparent, but will work if kept thin: Payne's Gray, Ivory Black, Burnt Sienna, Raw Sienna and Burnt Umber.

painting. When dry, glaze the alkyd colors over them to see the effect the glaze has on each color. The more transparent the colors are, the more effective the glaze. Now repeat the process, this time adding a small amount of Zinc White oil (Zinc White isn't available in alkyd) to the glaze. Don't use Titanium White as it is very opaque; Zinc White gives a translucent effect. Glazes containing white fall somewhere in between glazing and painting. These charts will give you an idea of the color effects that can be achieved with glazes. The colors are mixed optically, so two colors that would result in mud if mixed on the palette can be glazed to produce a glowing color.

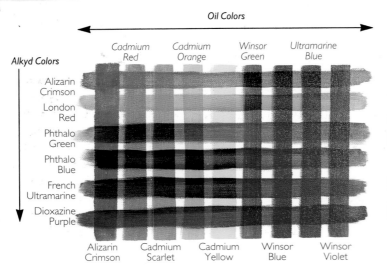

*Transparent alkyds glazed over oil colors*

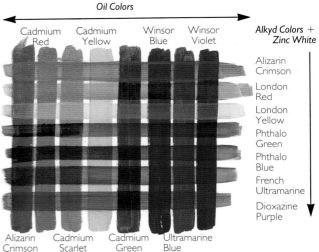

*Alkyd glazes mixed with a small amount of Zinc White and glazed over oil colors*

# Old Angus

## Materials Used in Finished Painting

### ALKYD PAINTS

- Alizarin Crimson (transparent)
- Cadmium Red Light (opaque)
- Cadmium Red Medium (opaque)
- London Red (transparent)
- London Yellow (transparent)
- Cadmium Yellow Medium (opaque)
- Phthalo Green (transparent)
- Phthalo Blue (transparent)
- Dioxazine Purple (transparent)
- Burnt Sienna (semitransparent)
- Burnt Umber (semitransparent)
- Ivory Black (semitransparent)
- Titanium White (opaque)

### OIL PAINT

- Zinc White (transparent)

### BRUSHES

- no. 0 watercolor round
- no. 2 watercolor round
- no. 8 watercolor round
- no. 3 Winsor & Newton series 240 goat-hair wash brush
- 2-inch (5.1cm) housepainter's brush

### OTHER

- 12″ × 16″ (30.5cm × 40.6cm) stretched and prepared fine-weave canvas
- carbon or charcoal pencil
- Liquin

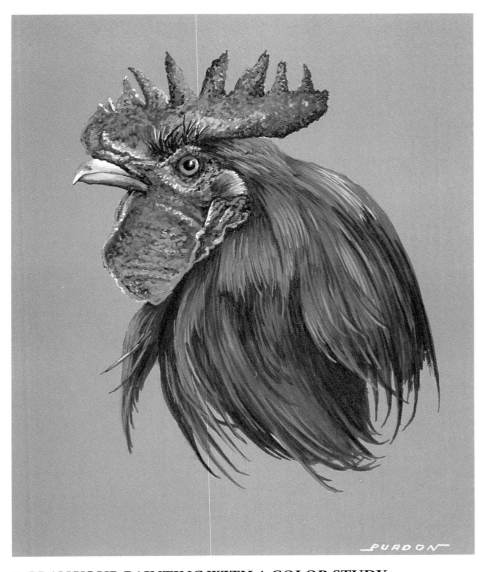

## 1. PLAN YOUR PAINTING WITH A COLOR STUDY

I don't normally paint animals, but when I saw this rooster I knew I had to paint him. I was on a painting trip in Scotland and staying at a small hotel. One day I was looking over my sketches outside the hotel when he appeared. He seemed as interested in me as I was in him, so I was able to do some quick sketches and take some photographs. I found out later from the staff that his name was "Old Angus." Using my photographs and sketches, I did this small study in gouache. I will now use this study as reference for an alkyd painting. The alkyds will allow me to intensify the colors and to complete the painting using transparent glazes. I won't do a color pool for this painting since I have established the colors needed in the gouache study. I will use mixtures of opaque and transparent colors for the painting, working them back and forth to utilize the transparent glazes.

## 2. TONE THE CANVAS AND BLOCK IN THE DRAWING

Tone the canvas with a transparent mixture of Burnt Sienna and Alizarin Crimson using the 2-inch (5.1cm) housepainter's brush. Unlike the previous paintings, don't apply the paint evenly, but darken it at the corners. When dry, transfer the drawing to the canvas with a carbon pencil. When the drawing is complete, go over it carefully with a diluted mixture of Phthalo Green and Burnt Umber. When working with the alkyds you can get striking color effects by working complementary colors over each other. The rooster's head is bright red and the body is a golden brown, which is a low-chroma red, so paint shadows and details of the head and body in Phthalo Green, the complementary of red. Use Burnt Umber for the beak and the pupil of the eye as you don't want green to show through in these areas.

### *Complement Trick*

If you're in doubt as to the complement of any color, look at it for about a minute under a bright light and then immediately look at a piece of white paper. The color you see will be the complementary color.

## 3. APPLY THE FIRST GLAZE

For all the painting in the following steps use no. 0, no. 2 and no. 8 watercolor brushes. These brushes not only allow you to paint fine detail but are soft enough to apply glazes without leaving brushstrokes. Start to build up the colors using transparent glazes: First glaze the head with Alizarin Crimson and the body with a mixture of Dioxazine Purple and London Red. Brush the glaze on with a no. 8 watercolor round. When the area is covered, take a goat-hair mop brush and tap it gently over the glazed area, smoothing and removing paint until you like the effect. When the brush becomes saturated with paint, it must be cleaned, or a new brush must be used. Also use this method to produce a stippled pattern for textural effects. If an area becomes too dark you can use opaque color to reestablish the light. Due to the rapid drying time of the alkyds, this process isn't as time-consuming as it sounds.

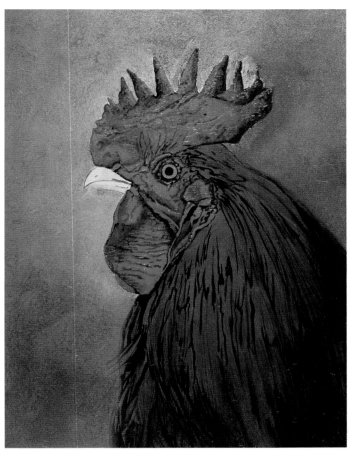

## 4. GLAZE THE BACKGROUND

The gray background I used in the gouache study looks too much like an illustration. A low-chroma green background will intensify the reds in the painting, so start to glaze mixtures of London Yellow, Phthalo Blue and Dioxazine Purple over the background.

### Creating an Alkyd Glaze

When glazing with alkyds, mix your colors with Liquin and a very *small* amount of mineral spirits so the glaze dries rapidly; it will be dry enough within one or two hours to allow you to continue painting.

## 5. ADD OPAQUE DETAILS AND BUILD UP GLAZES

When the first glazes have dried enough to work on, start to model the rooster's comb and add detail using Cadmium Red Medium and Alizarin Crimson mixed with Phthalo Green for the darks. Cadmium Red Medium is an opaque color, so apply the paint in small lines and dots with no. 0 and no. 2 watercolor brushes, allowing the previous color to show between. Paint the eye using Ivory Black for the pupil and Cadmium Red Light for the iris. Glaze the body with glazes of London Red, Alizarin Crimson and Phthalo Blue, creating a color closer to the actual brown of the body. Keep this area dark as you want to be able to build the feathers and show detail using a lighter value. Glaze the background with mixtures of Phthalo Blue, Cadmium Yellow and Alizarin Crimson mixed with Zinc White using a no. 8 watercolor round. Use a softening brush to remove the paint and smooth the glaze.

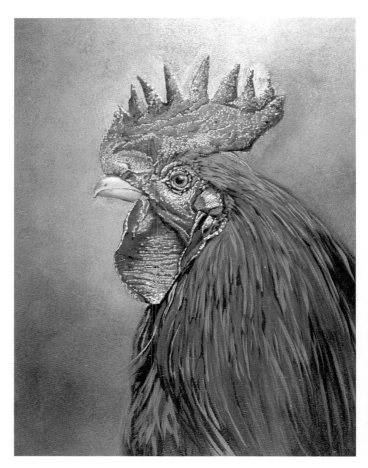

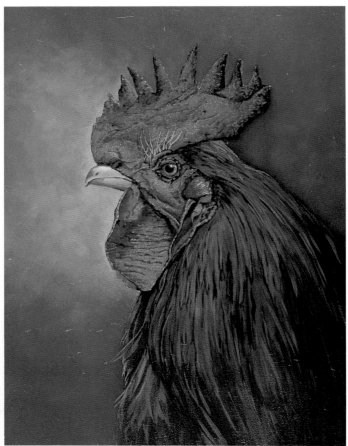

## 6. ADD OPAQUE HIGHLIGHTS

Now you can start to build up the modeling on the comb using a mixture of Cadmium Red (Light) and Titanium White. Correct the shape of the pupil and iris if they have lost their circular shape and add the eyelid to the eye. Paint the iris with Cadmium Red (Light) and then add the shadows with Burnt Umber and Alizarin Crimson. Use Titanium White to paint the highlight in the eye and Cadmium Yellow mixed with Cadmium Red (Light) to paint the small catchlight on the opposite side of the eye. Paint the beak using mixtures of Burnt Sienna, Burnt Umber, Cadmium Yellow Medium and Titanium White. Paint the light feathers on the body using Cadmium Red (Medium), Cadmium Red (Light) and Cadmium Yellow Medium.

## 7. USE GLAZES TO CORRECT VALUES

Mix a transparent glaze of London Red and Liquin and glaze over the highlights in the comb. Paint a glaze of London Yellow and Burnt Sienna over the body, gradually adding Dioxazine Purple toward the bottom of the painting. You don't want the body to compete with the head, so decrease its brilliance and definition. The background is too transparent, so repaint it with opaque colors. Mix low-chroma greens and paint them over the ground, blending them with a softening brush so some of the underpainting will show through. Keep the value and chroma low so the background won't compete with the subject.

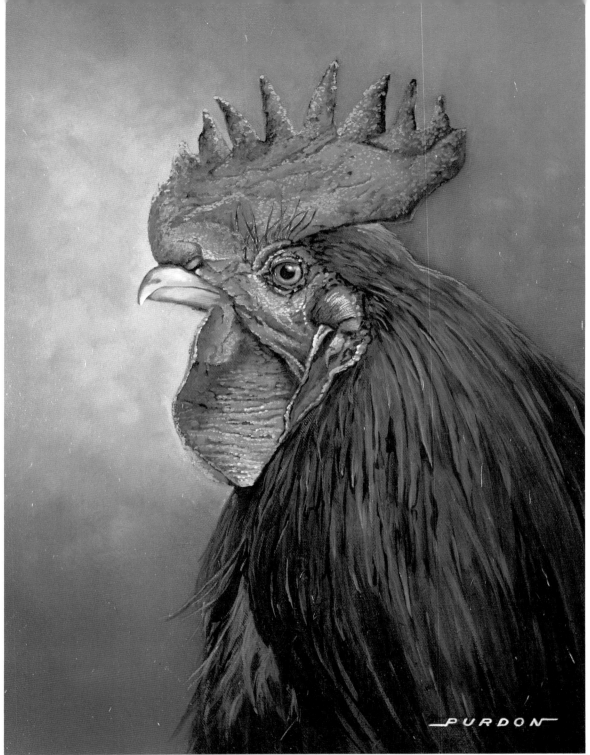

## 8. FINE-TUNING

Now refine details and apply impasto paint where you want it to catch the light using a no. 0 watercolor brush. If you want to decrease the value of an area use glazes of Alizarin Crimson, Dioxazine Purple or Phthalo Blue. When you finish the head, glaze the body using the same colors to deepen areas. Use Burnt Sienna, Cadmium Red Light and Cadmium Yellow Medium mixed with Titanium White for the light details of the feathers. You can now sign the painting, put it in storage for a few days and then look at it with fresh eyes. When you work on a painting daily you can overlook small things that become evident when you view it afresh. Correct any problems and store the painting for a month before varnishing.

# Sheldaig Island—Evening

## Materials Used in Finished Painting

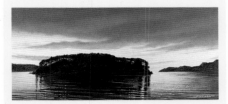

### ALKYD PAINTS
- Alizarin Crimson
- London Red
- Cadmium Red Light
- Cadmium Yellow Medium
- London Yellow
- French Ultramarine
- Dioxazine Purple
- Titanium White

### OIL PAINTS
- Indigo
- Titanium White
- Zinc White

### ACRYLIC PAINTS (Optional)
- Ultramarine Blue
- Titanium White

### BRUSHES
- no. 7 bristle filbert
- no. 0 watercolor round
- no. 2 watercolor round
- no. 8 watercolor round
- Winsor & Newton University series ½-inch (1.3cm) acrylic flat
- no. 3 Winsor & Newton series 240 goat-hair wash brush
- no. 2 angle chisel ColourShaper

### OTHER
- 12″ × 24″ (30.5cm × 61cm) stretched and prepared fine-weave canvas
- Liquin

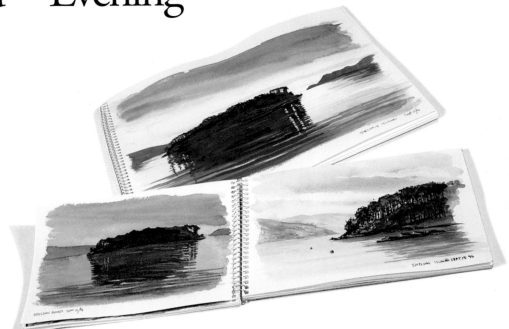

## 1. START WITH A SKETCH

This is a painting from the village of the Sheldaig, looking over the loch to the island. As I stayed there for several days I was able to complete many watercolor studies of the sunsets. These sketches will provide the material for this demonstration. The added transparency and brilliance of alkyds are a real advantage when painting a subject like this.

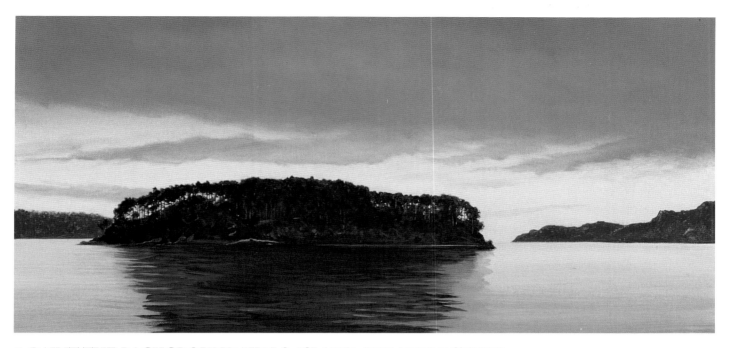

## 5. PAINT THE BACKGROUND HILLS, ISLAND AND REFLECTION

Paint the hills using Indigo, French Ultramarine and Dioxazine Purple mixed with a small amount of Zinc White. This mixture will be almost opaque, allowing just a little of the sky color to show through. Controlling the value of these hills is tricky—they should be lighter than the island, but if they're too light, they'll detract from the brightness of the sky and give a false illusion of depth. Paint the island using Indigo and a small amount of white to lighten it slightly and to give it covering power. The island will be the darkest part of the painting. You want to create the effect of light shining through the trees, so leave gaps in the foliage. When the island is painted and before the color starts to dry, use a ColourShaper to lift some of the paint, indicating tree trunks and rocks. If you don't have a ColourShaper, a similar effect can be achieved by using the sharp edge of a white plastic eraser. This will keep the island from looking like a "black hole." Don't be too concerned with detail at this stage; once the sky and water are finished, you might want to add more detail, but right now concentrate on overall effects. Using a no. 6 acrylic flat and the island color, deepen the reflection and start to model the wave forms.

*Detail of above.*

ColourShaper used to remove paint to indicate rocks.

Tree trunks painted with a no. 10 watercolor round.

ColourShaper used to scrape paint to indicate tree trunks.

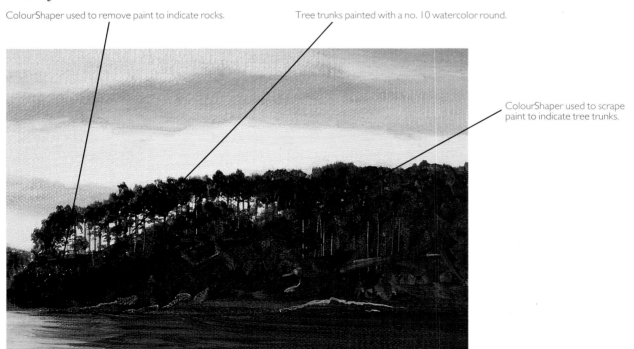

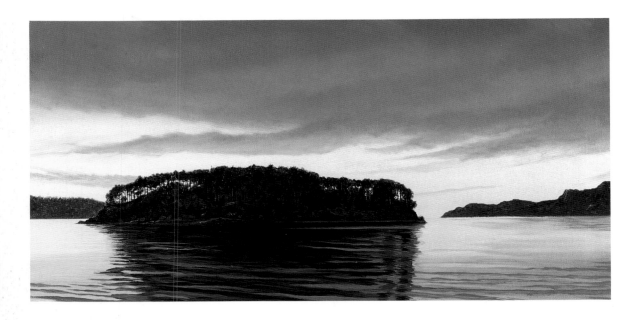

## 6. PULL THE PAINTING TOGETHER

Start by adding subtle colors to the sky, mixing warm and cool violets for the clouds using Dioxazine Purple, Alizarin Crimson, Cadmium Red Light, French Ultramarine and Titanium White. Switch from Zinc White to Titanium as you now want the colors to have more covering power. Apply the paint and then soften and remove it until you have the soft effects of the light. This isn't a true glaze as the colors used aren't transparent, but once they're softened they still allow the underpainting to show through. If you don't like the result, you can easily remove the paint with linseed oil. The color often looks quite different on the palette than on the painting, so it is often necessary to remove it, remix the color and try again. Once you have applied these glazes, use a softening brush to remove the paint and soften edges. Now place a transparent glaze of Dioxazine Purple and Alizarin Crimson over the details of the island you lifted with the ColourShaper. Glaze Alizarin Crimson over the water in the foreground, softening the edge. Put a glaze of London Red, which is a transparent red, on the edge

of the trees on the island where they meet the sky. This will give the effect of light scattering through the foliage. The hills on the distant shore are too purple so glaze over them with a mixture of Indigo and Cadmium Red Light to deepen the value and change the color. Now start to develop the wave pattern on the water using Indigo and a violet made with French Ultramarine, Indigo and Dioxazine Purple mixed with Titanium White. Use the ½-inch (1.3cm) acrylic flat for this step as it will not only apply the paint but also remove it if necessary, revealing the underlying color. You want to keep sharp edges between the areas of light and dark, which is difficult to achieve while the paint is still wet, so allow it to dry overnight before continuing. When dry, deepen the value and color of the top of the sky with a glaze of French Ultramarine and Dioxazine Purple. Use this same glaze on parts of the island and the foreground. When you finish these glazes, mix up the opaque color for the lights and darks for the water, and paint the ripples on the water and the reflections on the headlands.

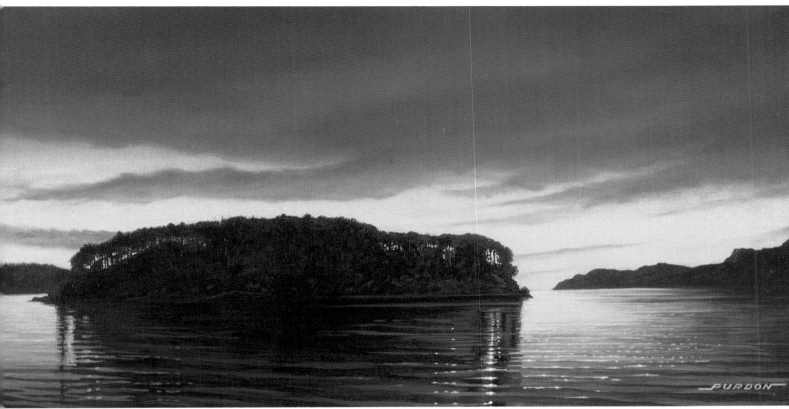

SHELDAIG ISLAND—EVENING
*12" × 24" (30.5cm × 61cm)*
*Collection of Mr. & Mrs. Kevin Moloney, Canada*

## 7. FINE-TUNING

In this step you will make the final adjustments to the drawing, color and values. This will be done using opaque, semiopaque and transparent colors. This step is where the quick drying time of the alkyds is a great help: With the exception of impasto applications, you can overpaint areas in less than an hour. Darken the reflection of the distant hills and land in the water using glazes of Dioxazine Purple, French Ultramarine, Indigo, Alizarin Crimson and Titanium White. Adjust the values and colors of the water using mixtures of opaque and semi-transparent colors. To make the water come forward, strengthen the values and color in the foreground. Make a mixture of impasto paint to match the sky color and use a no. 0 watercolor round to apply small dots to the water to make it sparkle. The small additions made in this step make the painting come to life and achieve a glow and inner light. The painting can now be allowed to dry for about a month to six weeks and then varnished.

If you look at the colors used to give the illusion of light, notice that none are high-chroma colors. The effect of light is achieved through the use of values. To demonstrate this I have placed a black-and-white card on the painting. You can see that even the lightest areas in the painting are reduced in value when compared with white, but still look light when seen against the strong darks of the land.

# 4 Building a Painting

In this chapter we'll put everything you learned in the previous chapters together to show you how to build a painting. We'll do four paintings, starting with a simple landscape and finishing with a large, complex seascape. Let's start painting!

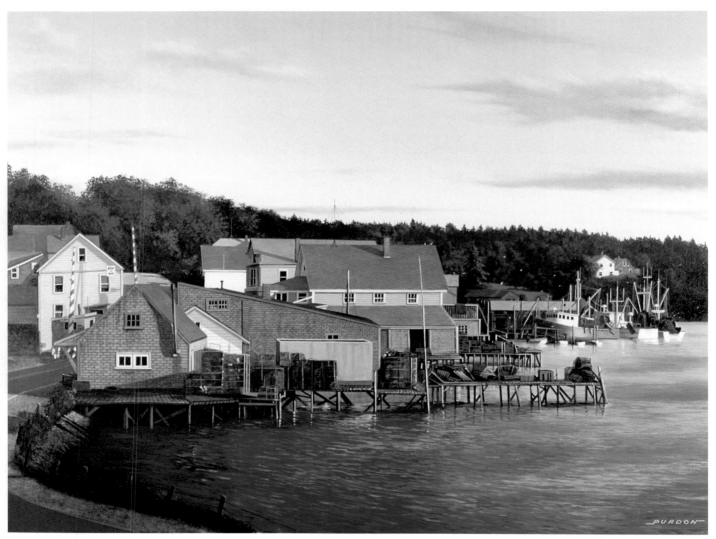

BRISTOL HARBOR—EVENING
*oil on canvas, 30" × 40" (76.2cm × 101.6cm)*
*Collection of Mr. Garrett Herman, Toronto*

# October Morning

## Materials Used in Finished Painting

### OIL PAINTS

- Alizarin Crimson
- Old Holland Naples Yellow Extra Deep
- Winsor Blue
- Burnt Umber
- Titanium White
- Raw Sienna
- Winsor Violet

### ACRYLIC PAINTS (Optional)

- Raw Sienna
- Dioxazine Purple (substitute for Winsor Violet)

### BRUSHES

- no. 8 bristle filbert
- ¼-inch (0.6cm) acrylic flat
- no. 0 watercolor round
- no. 2 watercolor round
- no. 3 Winsor & Newton series 240 goat-hair watercolor brush or badger fan blender
- old, splayed no. 8 watercolor brush
- 2-inch (5.1cm) housepainter's brush

### OTHER

- 12" × 16" (30.5cm × 40.6cm) stretched and prepared fine-weave canvas
- carbon or charcoal pencil
- Liquin

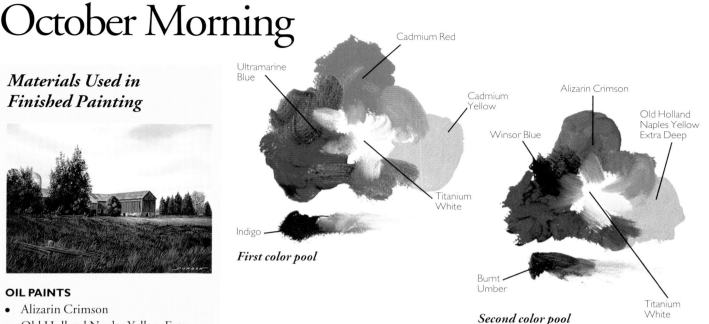

First color pool

Second color pool

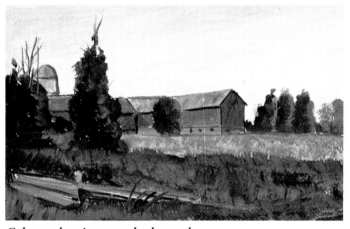

Color study using second color pool

## 1. EXPERIMENT WITH COLOR POOLS AND A COLOR STUDY

On the way to an appointment one morning last autumn I decided to take the back roads to avoid the traffic and came across a farm with a red, weathered barn catching the early morning sun. The colors surrounding the barn were no longer summer colors; the landscape had changed to autumn. I did a small pencil sketch, making color notes in the margin. I wanted to keep the muted colors of autumn, so I knew I'd have to use a different palette than for a summer scene. As a starting point, I made a color pool with Cadmium Red, Cadmium Yellow, Ultramarine Blue and Indigo. The red and yellow were too chromatic (intense) and the blue was too cool—it would have suited a winter sky more than an autumn one. I decided to use low-chroma colors: Alizarin Crimson, Naples Yellow Deep Extra and Winsor Blue, a warm blue. This is a very basic pool of three primary colors. Burnt Umber replaces the Indigo in the previous pool. When mixed with Winsor Blue, Burnt Umber will give me an excellent dark with warm overtones. To see the effects possible with these colors I did a small color study. When I saw how well the colors worked in the study, I knew these were the colors for this painting.

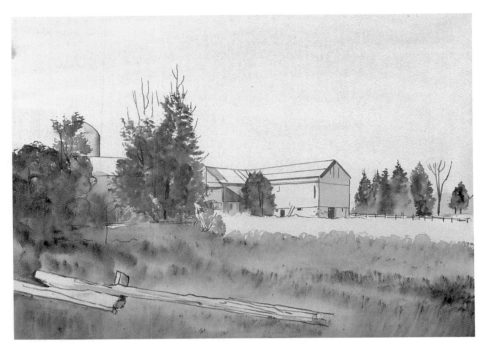

## 2. BLOCK IN THE DRAWING AND TONE CANVAS

Draw the scene onto your canvas with a carbon pencil, then use Dioxazine Purple acrylic to go over the drawing and block in the values. Tone the canvas with a light stain of Raw Sienna acrylic, giving it a light golden color. This will keep the overall mood of the painting warm. Acrylic dries quickly so you can proceed with the next step in a few minutes. (You can use oil thinned with Liquin for this step, but must allow it to dry for at least a day to prevent it from blending into the other colors when you start to paint.)

## 3. PAINT THE SKY AND BLOCK IN THE FOREGROUND

Place Titanium White on your palette and add Liquin to it, mixing it thoroughly. Divide the mixture into two parts, one for the clouds and the other for the blue of the sky. The color for the clouds is Titanium White mixed with a small amount of Naples Yellow Extra Deep and Alizarin Crimson. The basic sky color is Winsor Blue and Titanium White. Add a small amount of Winsor Blue and Alizarin Crimson to this mixture for the deeper blue at the top of the sky. Because Winsor Blue and Alizarin Crimson are intense colors, rather than adding the colors straight from the tube and risking making them too strong, mix a small amount of the colors with a small amount of white to make a tint, then add this tint to the mixture. Paint the sky loosely with a no. 8 bristle filbert and then soften it with a goat-hair blending brush (you could also use a soft fan brush). Try to capture a sense of movement in the sky. The layer of paint should be thin enough that the drawing will still show through. The foreground is in shadow, so paint a broken glaze of Burnt Umber and Winsor Blue over it to start to establish the values.

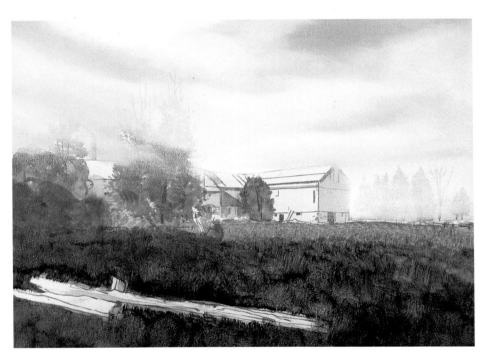

### *Teach an Old Brush New Tricks*

You've probably noticed that I do a lot of painting with old, worn brushes. I use them to establish texture and to build up broken glazes and colors. It's hard to achieve the textural effects they produce any other way. I never throw an old brush out before I bash, bend, cut or smash it to see what effects it could give. As they become more worn, the variety of effects the brushes can produce increases. When using worn brushes, remember that they are still a brush and paint with them—don't just dab away randomly.

## 4. PAINT THE BARN, TREES AND FOREGROUND GRASS

When the previous step is dry, you can start to paint the barn and trees using a no. 2 watercolor brush and an old, worn brush. As you are using only four colors, the color mixing is straightforward. Your darks can be made by mixing Winsor Blue and Burnt Umber, which will give you a deep green or brown. If you mix Winsor Blue, Alizarin Crimson and Burnt Umber you get black. Paint the barn using Alizarin Crimson, Burnt Umber and a small amount of Naples Yellow Extra Deep, adding more Burnt Umber and Alizarin Crimson for the side in shadow. Keep the values reduced at this stage so you can use lighter paint in the next step to indicate the sunlight catching the barn. The gray for the roof and silo is made with a mixture of Winsor Blue, Alizarin Crimson, Burnt Umber and Titanium White. Paint in the trees using an old, splayed watercolor brush and a mixture of Winsor Blue and Burnt Umber. When you finish the trees, add a small amount of Naples Yellow Extra Deep to the remaining tree mixture and use an old brush to build up the patterns of grass and weeds in the foreground. Allow the painting to dry.

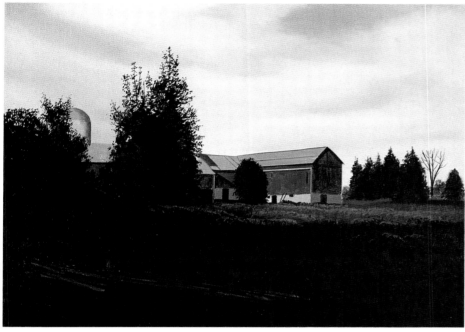

## 5. DETAIL THE SIDES OF THE BARN AND ROOF

With a lighter red, add the boards catching the sunlight on the sides of the barn, using the mahlstick to keep the lines straight. Mix a dark for adding the details. Due to the size of this painting and the level of finish, most of the detail painting will be done with the no. 0 watercolor brush. Once you have completed the sides of the barn, add the details to the roof using a ¼-inch (0.6cm) acrylic flat and a mahlstick held at the angle of the roof as a guide for painting straight lines. Paint the roof sections with one stroke, holding the brush parallel to the top of the roof. Vary the shade and color for each stroke so that each sheet of steel will look different. Paint the foundation stones.

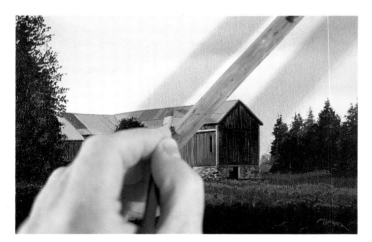

## 6. PAINT THE STRAIGHT EDGES

When you have finished painting the roof, use a no. 0 watercolor brush and the mahlstick as a guide to paint the straight edges of the barn. Here I am ruling a line for the top of the roof. I use the mahlstick whenever I want to paint a straight line. Hold your brush in the usual way, then allow your fingernails to slide along the mahlstick. It takes a bit of practice but is worth the effort.

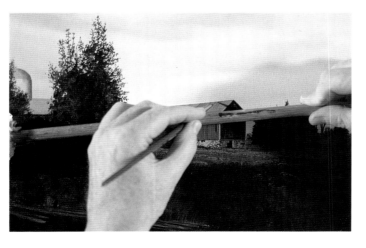

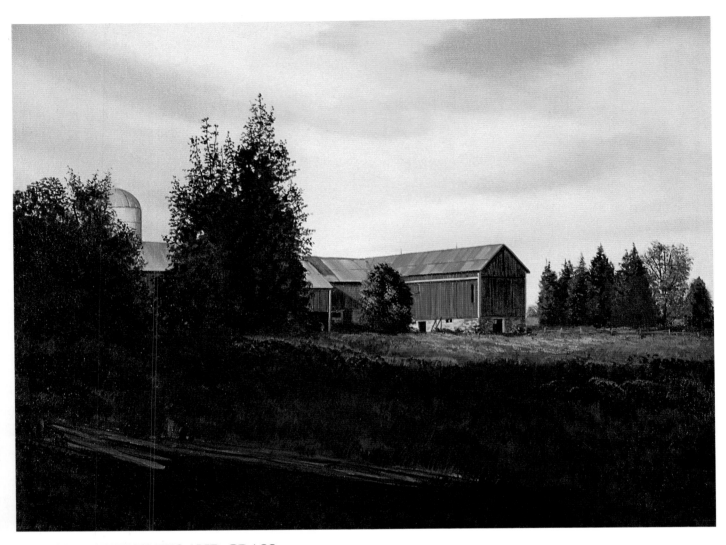

## 7. DETAIL THE TREES AND GRASS

The lightest areas on the dark trees are made using Burnt Umber, Winsor Blue and Naples Yellow Extra Deep. For the fall colors of the other tree use Alizarin Crimson, Burnt Umber and Naples Yellow Extra Deep. When painting trees use a very light touch. Allow the paint to just catch the weave of the canvas. This will give you soft edges that will look like leaves. When you have finished the trees, paint the grass using an old watercolor brush to create a broken application of color. Keep both the intensity and the values re-duced slightly so this part of the painting will recede. Once you have finished with the background trees and grass, refine the trees in the foreground using a no. 0 watercolor brush and a mixture of Winsor Blue and Burnt Umber to add details of leaves and branches. Apply glazes of Alizarin Crimson, Naples Yellow Extra Deep and Burnt Umber to part of the roof of the barn to deepen the effect of weather stains and rust. Paint the lightning rods on the barn with Burnt Umber thinned with Liquin.

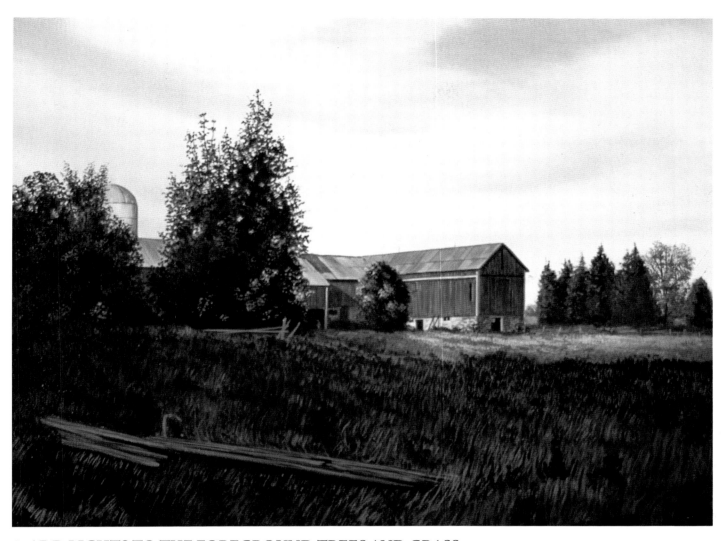

## 8. ADD LIGHTS TO THE FOREGROUND TREES AND GRASS

Mix a light green from Winsor Blue and Naples Yellow Extra Deep to paint the leaves that are catching the light on the foreground trees, using a no. 0 watercolor brush. Paint the split-rail fence in the foreground using a dark made with Winsor Blue, Burnt Umber and Alizarin Crimson, and grays made by adding Titanium White to the darks. Again, keep the values reduced so you'll be able to add the textures with lighter paint. Using the old watercolor brush and mixtures of browns and greens, stipple in the textured underpainting that you will use as the starting point to paint the grass. Mix this paint quite thin so you won't have difficulty covering it later. Allow this to dry and the painting can be completed in the next step.

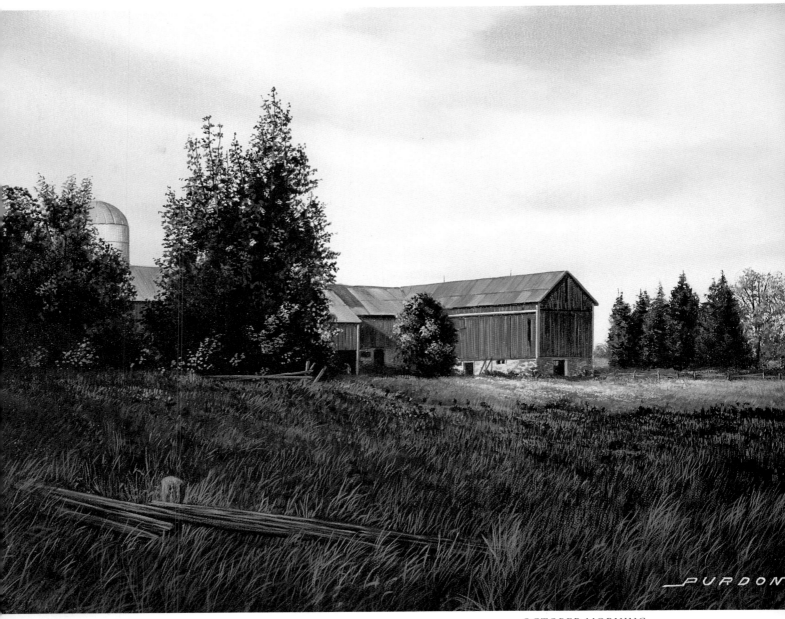

OCTOBER MORNING
*12" × 16" (30.5cm × 40.6cm)*

## 9. FINE-TUNING

Using the no. 0 brush and mixtures of greens and browns, paint in the grass. This step isn't as time-consuming as it looks. What you're really doing is weaving fine lines of different colors one over the other, similar to crosshatching, and this can be done very quickly. Keep the values in the lower ranges so you can add lights when they dry. Add details to the fence and use glazes of Winsor Blue and Burnt Umber to reduce the value and indicate shadows. Mix lighter values of the colors you used for the grass and selectively paint in detail. Keep the foreground reduced in value so it won't spoil the effect of light on the barn. Once the grass is completed, add final details to the fence and sign the painting.

# Kew Cottage

## Materials Used in Finished Painting

### OIL PAINTS
- Permanent Rose
- Cadmium Red
- Cadmium Yellow
- Winsor Green
- Ultramarine Blue
- Titanium White
- Lemon Yellow
- Winsor Violet

### ACRYLIC PAINTS (Optional)
- Lemon Yellow
- Dioxazine Purple

### BRUSHES
- no. 4 bristle filbert
- no. 7 bristle filbert
- no. 0 watercolor round
- no. 2 watercolor round
- old, splayed no. 8 watercolor brush
- no. 3 Winsor & Newton series 240 goat-hair watercolor brush or badger fan blender
- 2-inch (5.1cm) housepainter's brush
- ColourShaper
- no. 10 chisel ColourShaper (firm)

### OTHER
- 18″ × 24″ (45.7cm × 61cm) stretched and prepared fine-weave canvas
- carbon or charcoal pencil
- Liquin

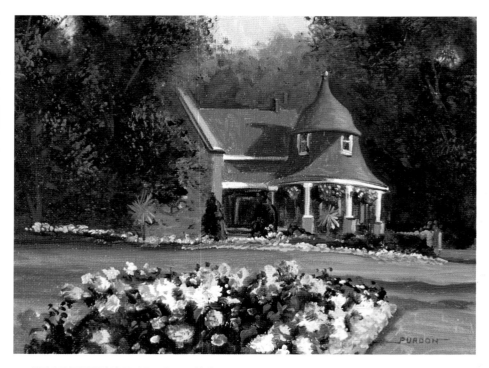

## 1. START WITH AN OIL STUDY

This painting is a scene of the gardener's cottage at Kew Gardens in Toronto, Canada. The cottage was built in 1902 as a residence for Mr. Kew Williams, after whom the gardens are named. The gardens are especially colorful in early summer, when I did this small oil study. I painted the study in about two hours as I wanted to get it finished before the light changed. For this chapter I wanted to include a painting demonstrating colors used full strength and decided to expand this study into a larger painting.

### Painting on Location

The above study was done with my small, traveling set of oils. When I paint on location, my palette of colors is Alizarin Crimson, Winsor Red, Winsor Yellow, Winsor Green, Winsor Blue, Ultramarine Blue and Titanium White. Using these colors, I can mix almost any color I need. Excellent darks can be made by mixing Alizarin Crimson and Winsor Green, or Winsor Blue and Winsor Red. I buy the 0.7 oz. (21ml) tubes for the colors and a 2 oz. (60ml) tube of Titanium White to keep my paint box light enough to carry.

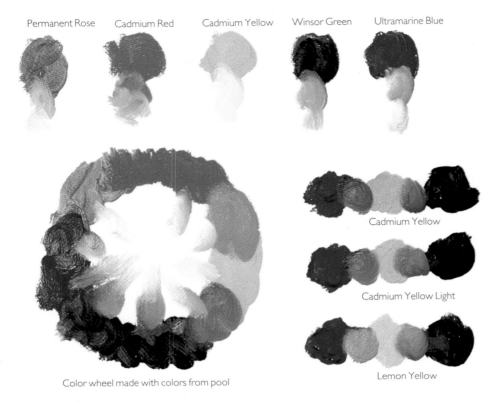

Permanent Rose    Cadmium Red    Cadmium Yellow    Winsor Green    Ultramarine Blue

Cadmium Yellow

Cadmium Yellow Light

Lemon Yellow

Color wheel made with colors from pool

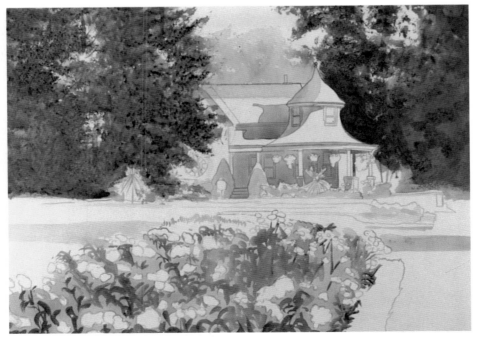

## 2. EXPERIMENT WITH COLOR POOLS

Now I must decide on colors for the larger painting. Remember that when enlarging a small oil study to a large painting, you can use far stronger colors in a small painting than in a large one. If I copied the colors of the study exactly, the resulting painting would be too brilliant and look unnatural. I used the Winsor colors for the study as they are inexpensive and can be intermixed to produce bright, clean colors. However, they are transparent and don't work as well for impasto painting as the Cadmiums, which are opaque. I substitute the Cadmium Red and Yellow with Winsor Red and Yellow, but keep the Winsor Green and Ultramarine Blue, which will work nicely for thin, transparent darks. Cadmium Yellow is warmer than the Winsor Yellow—this will help warm the painting. When I did the small study I used Alizarin Crimson for the pink flowers; I want to make them brighter so I will use Winsor & Newton Permanent Rose to produce brilliant pinks. I now make a color pool to see how these colors will work together. The Cadmium Yellow seems rather warm and I wonder if I can replace it with either Cadmium Yellow Light or Lemon Yellow. As I will be mixing the yellow with blue and green, I test each yellow mixed with Winsor Green and Ultramarine Blue. When completed, I decide I still like the result of the Cadmium Yellow best. It's a good idea to experiment with different colors, even if you think the one you have is the correct one; often you will discover an unlikely color will work better.

## 3. BLOCK IN THE DRAWING AND TONE CANVAS

Draw the scene on the canvas using a carbon pencil. When finished, reinforce the drawing with Winsor Violet and at the same time block in the values. When this is dry, the canvas can be toned. As this is a bright summer scene, you want the painting to be bright and sunny, so the canvas should be toned with a color that will enhance that effect. In this case the obvious choice is yellow. Apply a transparent stain of Lemon Yellow to the canvas using a housepainter's brush. The stain will change the violet block-in to a soft brown.

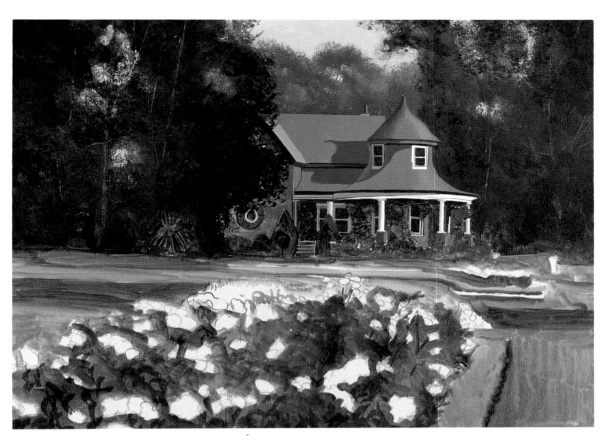

## 4. BLOCK IN THE PAINTING

After the ground has dried you can start painting. The background and house should be painted first so the darker values can be established, allowing you to judge the values in the foreground. These will be blocked in and the details added later. You don't want a bright blue sky but one that belongs to the hot days of summer. Mix Ultramarine Blue with Titanium White, then use a gray made from Winsor Violet and Permanent Rose to gray it down. The resulting color is a bit too cool, so add a small amount of Cadmium Yellow to warm it up. Using a generous amount of Liquin to keep the paint fluid, block in the trees using mixtures of Winsor Green, Winsor Violet and Ultramarine Blue, using an old, splayed brush to produce the effect of foliage. Mix a small amount of Titanium White and Cadmium Yellow with these colors to indicate the direction of light on the trees. Use the ColourShaper to remove paint, allowing the ground to show through to indicate the branches and trunks of the trees. When you finish painting the trees you might find that the paint has built up in places. You want to keep this area thin so it's a good idea to re-

move some of the paint by "tonking" (see sidebar). Since you aren't using Indigo or black in this painting, you must mix your own darks. Excellent darks can be made with either Cadmium Red and Ultramarine or Winsor Green and Permanent Rose. These darks can be shifted toward red, blue or green, depending on the color you'll be using them with. Start painting the house, using Winsor Green, Ultramarine Blue, Cadmium Red and Titanium White for the roof and the same mixture with more red for the stone of the cottage. The trim is painted using Titanium White for the light and Titanium White mixed with the dark made from Cadmium Red and Ultramarine Blue—this dark is also used to paint the shadows and the panes of the windows. Don't try to achieve too much detail at this stage; that can be added once you've established the basic shapes and colors. The cottage and trees are the background of this painting; there will be a very shallow middle ground from the cottage to the flower beds in the foreground. To keep the trees and cottage in the background, keep the intensity of the colors and values slightly reduced.

Remember that warm colors advance and cool colors recede. Use thin mixtures of Ultramarine Blue, Winsor Green and Cadmium Yellow mixed with Liquin and start to block in the middle ground and foreground of the painting. Don't try to paint any details at this step—just cover the underpainting and establish the general colors and values. When this step is finished, allow the painting to dry before continuing with the next step.

### Tonking

One way of removing excess paint without damaging what you've painted is called *tonking*. Lay a couple of sheets of a newspaper over the area where you want to remove paint. Then, using the palm of your hand, press the paper onto the canvas so it will absorb some of the paint and oil. *Don't move the paper while you are doing this.* Allow the paper to absorb the paint for a couple of minutes, then peel it off the canvas. You can repeat this process until you have removed as much paint as you wish.

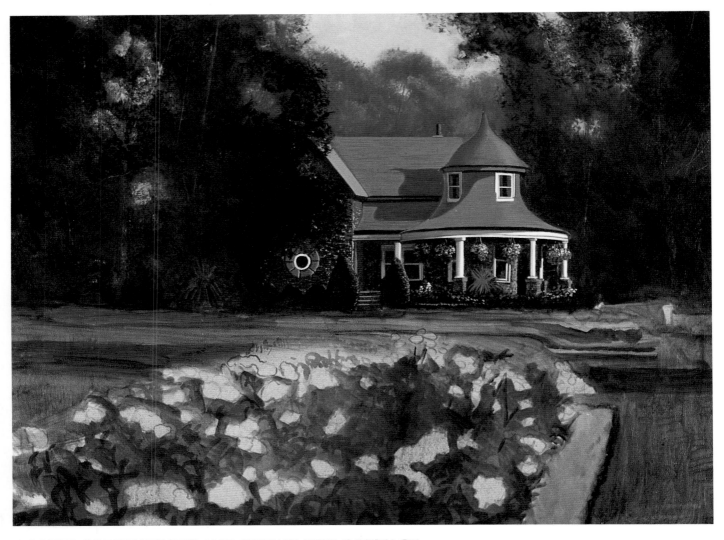

## 5. MAKE CORRECTIONS AND DETAIL THE COTTAGE

The turret of the house is out of symmetry, so it must be corrected before continuing. The drawing must be correct; otherwise it will ruin a good painting. The background trees are too warm so glaze them with a mixture of Ultramarine Blue, Cadmium Red and Titanium White, using just enough white to give the glaze some opacity. Now start to add detail to the cottage using opaque paint. While painting the house, check for other errors in perspective and make sure that all the verticals of the building are parallel. Remember that a circle must be either a true circle or, if seen in per-

spective, an ellipse. Continue painting the house, adding more detail and adjusting the values. When the house is finished, paint the flower baskets and the shrubbery in front of the porch. Reduce the intensity of the flowers slightly by adding a small amount of green to the red and pink flowers, and red and blue to the white flowers—these flowers shouldn't be as bright as the flowers in the foreground. Before finishing this step, place a glaze of Ultramarine Blue and Permanent Rose over the trees and the foreground to reduce the brilliance of the underpainting.

### Break It Down

When painting a complicated object, the easiest way to paint it is to break the process into three steps:

1. Paint the local colors and the basic forms using thin paint.
2. When dry, repaint—this time using full-bodied paint—making any corrections and bringing the object close to completion.
3. When the previous step is dry, use opaque paint and glazes to adjust the drawing, add fine details and adjust values.

## 6. DETAIL THE FOLIAGE AROUND THE HOUSE

Use an old, splayed brush to mass in the major shapes of the trees with mixtures of Winsor Green, Cadmium Yellow, Ultramarine Blue and Titanium White. Place a glaze of Cadmium Red and Ultramarine Blue over the trees to deepen their value and then paint leaf details into the wet glaze with opaque paint, using a no. 0 watercolor brush. Don't overwork the trees; if you feel they need more detail you can add it later. Now refine the modeling on the house using glazes of Ultramarine Blue and Cadmium Red. Where the sun is catching the white trim on the house, add Titanium White with a small amount of Cadmium Yellow. When you have completed the trees and cottage, start to paint the flowers around the house using Titanium White, Permanent Rose and Cadmium Red. The greens for the foliage can be made with mixtures of Winsor Green, Cadmium Yellow and Ultramarine Blue—using these colors, you can make many different values and shades of green. Using an old brush and a semitransparent green glaze, paint a lighter green over the grass.

### One Plane at a Time

Painting from top to bottom and from back to front is a good practice to follow. You focus on one plane of the painting at a time; therefore, you can keep your colors and values consistent.

## 7. START THE FLOWER BEDS

Mixing up different values and colors of greens, paint in the greenery of the flower beds. Paint the grass with two more opaque shades of green—one for the areas in sunlight and another for the cast shadows—still allowing a bit of the underpainting to show through. Using a transparent glaze of Winsor Green and Ultramarine Blue, glaze over the green in the foreground flower beds. Allow the paint to dry before finishing the foreground.

### *Cast Shadows*

Cast shadows are a good way to break up large areas of grass or snow in a painting. They also impart a sense of mystery to the painting, suggesting that there are objects outside of the picture plane. Always make cast shadows consistent with the direction of light in your painting.

## 8. PAINT THE FOREGROUND FLOWERS

The flowers in the foreground will be painted in directly with full-bodied paint. Paint them impressionistically so they have a fresh look and don't look overworked. The colors are still slightly reduced in value so that you can add the highlights with pure color in the last step. For each flower color, mix the local color (red, pink and white), separate it in thirds, then add white to one-third for the lights and more of the basic color to one-third for the darks. The white used for the white flowers, including the lights, is reduced in value by adding a mixture of Permanent Rose, Cadmium Yellow and Ultramarine Blue. Paint each flower using its local color. When all the flowers are painted, add modeling using the lights and darks you have mixed, working into the local colors to get soft edges. Don't overwork the flowers; you can always go back and make adjustments later. Mix a dark green with Winsor Green, Ultramarine Blue and Permanent Rose and paint the leaves and stems for the flowers. Use a mixture of Winsor Green, Cadmium Yellow and Titanium White to paint the border. When dry, add the final details to the foliage and flowers.

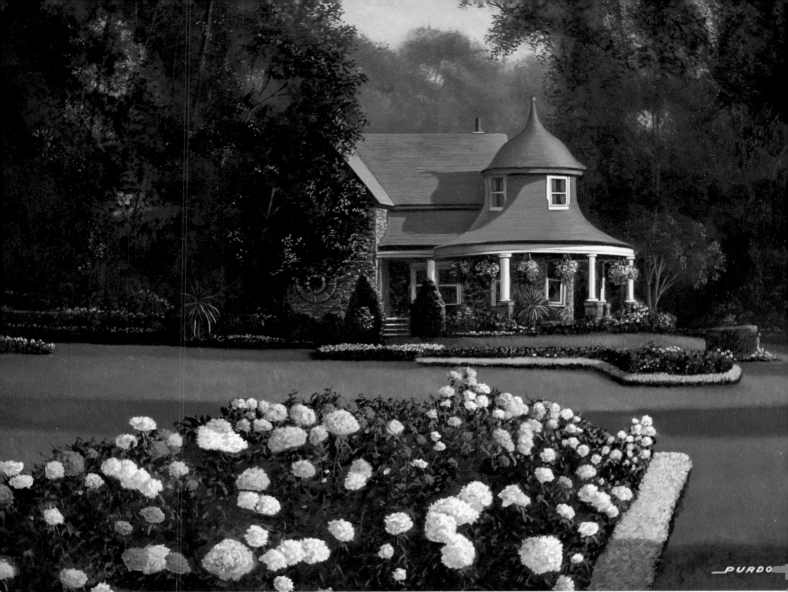

KEW COTTAGE
*18" × 24" (45.7cm × 61cm)*

## 9. FINE-TUNING

Use an old brush and darker greens to give the grass texture. Mix Winsor Green, Cadmium Yellow, Alizarin Crimson and Titanium White to make various values of green for the leaves and stems of the flowers in the foreground. You don't have to paint all the detail, just enough to allow the viewer's eye to fill in the rest. Mix Titanium White with Liquin, keeping the paint firm. Divide the paint in half and add a *small* amount of Cadmium Yellow to one part for the white flowers and Permanent Rose to the other for the pink flowers—you only want to add enough tint to keep the white from looking chalky. Using a no. 0 watercolor brush, apply the paint to the flowers to create high-

lights, keeping it impasto so it will catch the light. *Don't overdo it!* Use impasto Cadmium Red for the highlights on the red flowers and Cadmium Yellow for the yellow border highlights. If you find that your paint isn't firm enough, allow it to stand for a few hours on the palette and it will be easier to apply. When you've finished adding the impasto paint you can make a violet glaze using Permanent Rose and Ultramarine Blue and use it to adjust the values of the foliage and to indicate cast shadows on the leaves. Use a glaze of Permanent Rose to intensify the pink flowers. When the minor adjustments are complete, sign the painting and allow it to dry before varnishing.

### Prove It to Yourself

If you turn back to my original oil study, you will see how much brighter and more luminous this painting is due to the choice of colors and the use of glazing. Pooling my colors helped me produce a painting where all the colors have a common relationship. There is a clarity and brilliance in the colors you wouldn't get if you had used a wide range of colors. In addition, darks made from mixtures of high-intensity colors have a quality that can't be achieved with black. If you want to see the difference for yourself, copy my study, but use a full palette of colors and black for the darks. You'll notice quite a difference. I think you'll prefer the limited palette version.

# River Torridon and Sgurr Dubh

## Materials Used in Finished Painting

### OIL PAINTS

- Cadmium Scarlet
- Cadmium Yellow
- Cadmium Green
- Ultramarine Blue
- Winsor Violet
- Indigo
- Titanium White
- Flake White no. 2

### ACRYLIC PAINTS (Optional)

- Permanent Rose
- Transparent Yellow
- Dioxazine Purple (substitute for Winsor Violet)

### BRUSHES

- no. 4 bristle filbert
- no. 7 bristle filbert
- no. 6 acrylic flat
- no. 0 watercolor round
- no. 2 watercolor round
- old, splayed no. 8 watercolor round
- old, splayed watercolor flat
- no. 3 Winsor & Newton series 240 goat-hair watercolor brush or badger fan blender
- ¼-inch (0.6cm) flat acrylic brush
- ½-inch (1.3cm) flat acrylic brush
- 2-inch (5.1cm) housepainter's brush

### OTHER

- 24″ × 30″ (61cm × 76.2cm) stretched and prepared fine-weave canvas
- carbon or charcoal pencil
- Liquin
- mineral spirits
- lint-free rag

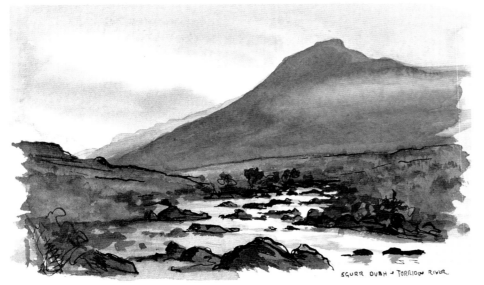

SGURR DUBH & TORRIDON RIVER

## 1. START WITH A WATERCOLOR STUDY

Glen Torridon in Scotland is one of the most dramatic places I have painted. The light is always changing as the clouds and mist move over the mountains and down the valley. I did this watercolor study on location in about twenty minutes. When you do a painting on location and work from it later, it's amazing how it brings the feeling of the place back to you, far more than a photograph would. It's a nice way to remember your trips.

Color wheel of the colors for the painting

## 2. TEST YOUR COLORS

I have a good idea of the colors that will work for this painting just by looking at the watercolor sketch. After you do lots of color pools, you can make a pretty good guess as to the colors to use, but it's still a good idea to do a pool and color study to make sure they will work. Making the pool will allow you to test-mix the colors so that the color mixing for the painting becomes easier. The colors selected are: Cadmium Scarlet, Cadmium Yellow, Cadmium Green, Ultramarine Blue, Winsor Violet and Indigo. With these few colors I am able to mix all the colors I'll need.

## 3. TONE THE CANVAS AND BLOCK IN DRAWING

Tone the canvas with a mixture of Permanent Rose and Transparent Yellow acrylic paints to give it a warm glow. This glow will show through in the lighter passages of the sky, adding a feeling of light. Transfer the drawing to the canvas using either a Conté or carbon pencil, keeping the drawing simple. Go over the drawing with a no. 0 watercolor brush and Dioxazine Purple acrylic. Block in the darks using a no. 7 filbert.

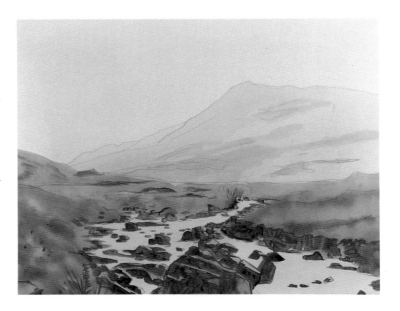

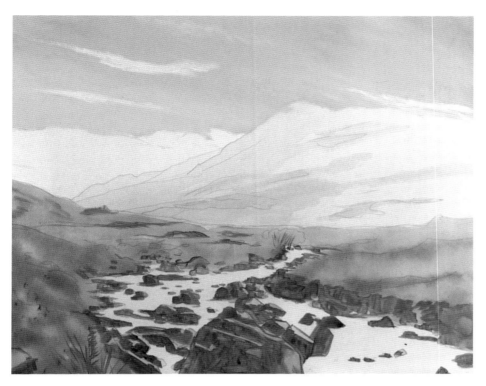

## 4. PAINT THE SKY

For the clouds, mix a large amount of Titanium White, Flake White no. 2 and Liquin, adding about two parts Titanium White to one part Flake White. To warm the white for the highlights on the clouds, you can mix a yellow that's very close to Naples Yellow by mixing Cadmium Scarlet, Cadmium Yellow and a small amount of Winsor Violet with the white mixture. The color for the sky is Ultramarine Blue mixed with a very small amount of Cadmium Scarlet and Winsor Violet. Divide this mixture into three separate parts and add Winsor Violet, Cadmium Scarlet, Ultramarine Blue and Indigo to make the three values of blue-gray for the sky. Paint the sky using a generous amount of paint, keeping in mind where you want the lights. Use a 2-inch (5.1cm) housepainter's brush to remove paint and soften the sky. Take a lint-free rag (not a paper towel), dampen it with mineral spirits and use it to lift paint where you want to add the lighter clouds.

## 5. PAINT THE CLOUDS AND THE MOUNTAIN

Paint the lighter clouds and soften them with a no. 3 goat-hair watercolor brush. Use a no. 3 filbert to paint the sharper edges on the clouds. You can only do so much at this stage as the paint is still wet. Use a palette knife to scoop the remaining cloud colors off your palette and put them in a 35mm film container (if you don't have one on hand, your local photo shop will probably give them to you). The container is airtight and will keep the paint fresh so you won't have to remix the colors if you need them later to adjust the shapes of the clouds. The color for the mountain is a darker value of the one used for the clouds; soften the edges of the mountain slightly so it won't look as if it were cut out of cardboard. Paint the mist while the mountain is still wet so it can be softened. Add a small amount of Cadmium Yellow and Titanium White to the mountain color to paint the foliage on the hills, but keep the values close or they will jump out of the picture. Don't put in too many details as you don't want the hills to compete with the foreground. Add the dark land form on the left of the painting so you have a dark value to judge the brightness of the sky against.

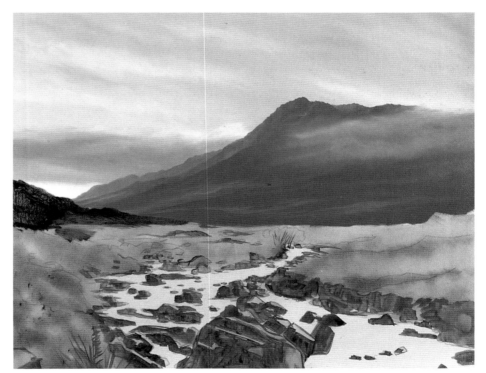

### *Painting Glowing Clouds*

Due to its reflective qualities, I often add Flake White to my mixtures when I'm trying to capture the glowing light in clouds. However, I find that used alone, Flake White lacks the covering power I need to work in thin layers.

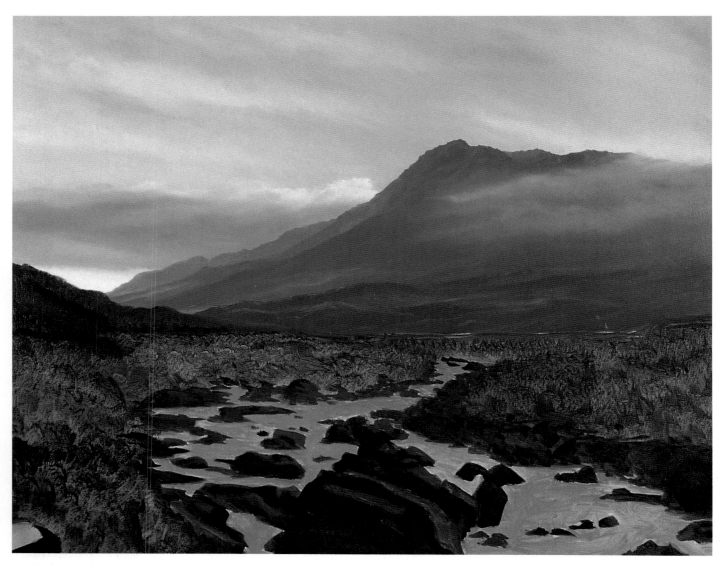

## 6. PAINT THE FOOTHILLS, STREAM AND ROCKS

Paint the foothills of the mountain using a slightly darker gray, adding some Titanium White and Cadmium Yellow to give the effect of light striking the raised areas. Mix a middle gray-blue using Ultramarine Blue, Indigo and Titanium White and dilute it with mineral spirits and Liquin so that it is fluid; paint the water of the stream, covering the underpainting but still allowing some to show through. Brush a mixture of Indigo, Cadmium Yellow and Winsor Violet mixed with Liquin and mineral spirits over the grass areas. Establish your dark values early so you will have a reference point to control your values: Mix Indigo with Liquin and mineral spirits and paint in the rocks of the stream, which will be the darkest values of the painting. When this is finished, the painting must be allowed to dry. Due to the thinness of the paint and amount of Liquin and mineral spirits used, it will dry overnight.

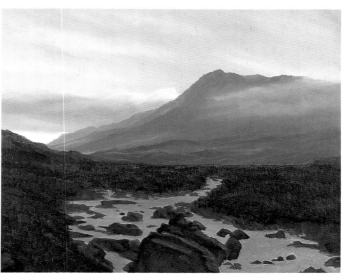

## 7. GLAZE THE UNDERGROWTH

Paint a glaze (actually more like a wash or stain) of Ultramarine Blue made with Liquin and mineral spirits over the land and water. This will reduce the value and change the color of the ground. This stain will dry enough in about half an hour so you can proceed with the next glazes. Make several dark glazes of Indigo, Cadmium Yellow and Ultramarine Blue, adding more Liquin than in the previous stain so the glazes aren't as fluid; they should not run when applied to the canvas. Apply these mixtures using the side of an old brush (as shown on left) to produce textures. Tap gently, leaving marks that look like grass in the wet glaze. This broken ground will show through when the lighter foliage is painted on top in the following stages to give the effect of undergrowth.

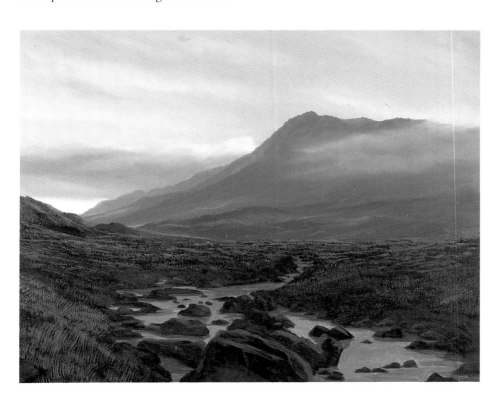

## 8. BUILD UP FOLIAGE AND GLAZE STREAM

Using an old watercolor brush, build up foliage patterns using mixtures of Cadmium Scarlet, Cadmium Yellow, Cadmium Green, Ultramarine Blue, Indigo and Titanium White. When dry, glaze over these patterns with Winsor Violet and Ultramarine Blue mixed with Liquin. Paint the lights again when the glaze has dried. This method of building up textures and then adding details to selected areas produces a very realistic look without actually painting each plant and blade of grass. When you finish the foliage, refine the shapes of the rocks and add lighter values to give them form. The darks are painted with Indigo and the lights with a gray made from Cadmium Scarlet, Ultramarine Blue and Indigo mixed with white. Before finishing this session, paint a thin, transparent glaze of Ultramarine Blue and Indigo mixed with Liquin over selected areas in the water, allowing the ground to show through. Make the glaze heavier in shadow areas on the water.

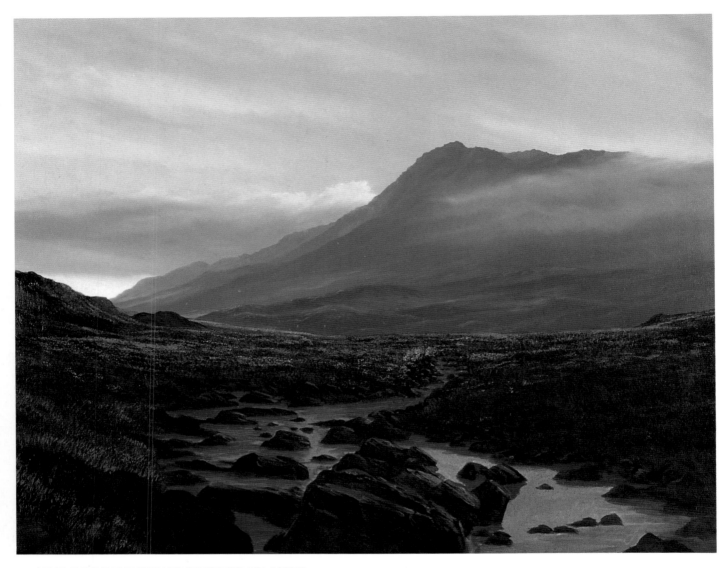

## 9. ADD MORE DETAILS WITH GLAZES

Build the details of the moor and rocks by placing transparent glazes of Ultramarine Blue and Winsor Violet over areas you painted in the previous step. Use an old brush and allow some of the previous painting to show through. If you use Liquin mixed with mineral spirits for these washes of color they will set in about half an hour, allowing you to paint on top of them without the color mixing into the lower layer. Using mixtures of Cadmium Scarlet, Cadmium Yellow, Cadmium Green, Ultra-marine Blue and Titanium White, add more details to the middle ground. The rocks still look flat, so use grays made with Cadmium Scarlet, Ultramarine Blue, Indigo and Titanium White to develop the planes of the rocks. Be sure to keep the values reduced as you want to have a wide range of values between the lights on the rocks and the light reflecting off the water. The water is still too light, so apply a further glaze of Indigo and Ultramarine Blue.

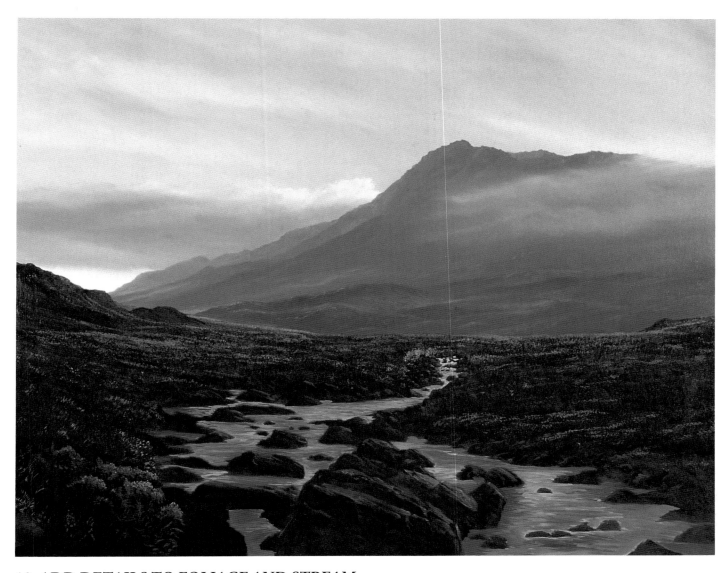

## 10. ADD DETAILS TO FOLIAGE AND STREAM

Deepen the foreground foliage with a glaze of Ultramarine Blue and Liquin. Mix greens and browns to paint details of leaves and grasses into the wet glaze. Don't try to paint each leaf and blade of grass; allow the viewer's eye to fill in the details. Mix Winsor Violet with Titanium White and paint the purple of the heather. To paint the water, first mix a midvalue blue-gray with Indigo, Winsor Violet and Ultramarine Blue, then mix a lighter value of the same color and use these to paint the ripples on the water. Keep the paint quite stiff and use a ¼-inch (0.6cm) and a ½-inch (1.3cm) flat acrylic brush to paint the water. Take advantage of the weave of the canvas to give the effect of sparkle on the water. Shadows cast by the rocks and banks on the water can be glazed in when the paint is dry.

## 11. FINE-TUNING

Using glazes of Ultramarine Blue and Indigo, darken the water where it's in shade and paint the shadows of the rocks. Use the same glaze to indicate shadows on the foliage in the foreground. When painting the water I covered some of the rocks and lost the shape of others; now you can repaint the rocks in the stream and adjust the drawing and values of those in the foreground. Mix two values for the water, using Ultramarine Blue, Winsor Violet, Indigo and Titanium White. The lightest mixture should be about a half-value from pure white and the other one about a value deeper. Using a ¼-inch (0.6cm) acrylic flat, paint in the ripples on the water. When you have finished the larger shapes for the water, mix Titanium White plus Flake White with a very small amount of Cadmium Yellow and add a little Liquin to it so it can be applied using a no. 0 watercolor round. Add this impasto paint where the water is catching the light. Using the same brush and mixtures of Cadmium Scarlet, Cadmium Yellow, Winsor Violet and Titanium White, add small dots of impasto paint to the rocks and heather in the foreground. Remember that detail is a product of light; you need very little detail in the shadow areas. When these adjustments are completed, sign the painting and allow it to dry before varnishing.

RIVER TORRIDON AND SGURR DUBH
*24" × 30" (61cm × 76.2cm)*
*Private collection, Canada*

### Moving Water

When painting a stream, remember the water is flowing and apply the paint in the direction of the flow. Water isn't static; it is a moving entity. Even a still pond will usually have ripples caused by the wind.

# Lobster Cove

## Materials Used in Finished Painting

### OIL PAINTS
- English Red
- Cadmium Yellow
- Prussian Blue
- French Ultramarine
- Indigo
- Titanium White
- Burnt Sienna

### ACRYLIC PAINTS (Optional)
- Burnt Sienna
- French Ultramarine

### BRUSHES
- no. 4 bristle filbert
- no. 7 bristle filbert
- no. 8 bristle flat
- no. 6 acrylic flat
- no. 0 watercolor round
- no. 2 watercolor round
- no. 6 sable bright
- no. 3 Winsor & Newton series 240 goat-hair watercolor brush or badger fan blender
- 2-inch (5.1cm) housepainter's brush

### OTHER
- 24″ × 36″ (61cm × 91.4cm) stretched and prepared fine-weave canvas
- carbon or charcoal pencil
- Liquin
- mahlstick
- masking tape
- white soft pastel

Photograph of Lobster Cove. Note how the horizon divides the picture in half.

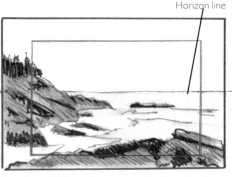

Drawing made from photograph, with the section I've selected for the painting indicated.

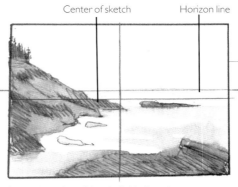

Selected portion of sketch divided into four parts. Horizon is still too close to horizontal center.

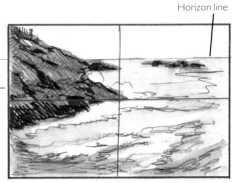

Final composition. Horizon moved up and foreground rocks deleted.

## 1. START WITH A PHOTO AND REWORK THE COMPOSITION

This painting will be based on a snapshot I took on Monhegan Island. Looking at the photograph, the temptation would be to copy it to the canvas and start to paint: This would be a mistake! What works for a small snapshot won't work for a large painting. I do an ink-and-wash drawing of the photograph and decide to use only the center portion of the photo. I mark the area I'm planning to use; as I do this I notice the horizon divides the picture completely into equal parts. This breaks one of the fundamental rules of composition: The horizon line should never divide the picture into two equal spaces. If you look at the lower section of the photograph, the land and sea divide the lower part of the painting into equal parts also, making the composition even worse. I redraw the central portion of the sketch, but this time move the horizon line

slightly above center. When I divide this sketch into four equal parts, I notice there will be one section with nothing but sky and another with only a small piece of land showing. Adding detail to the sky to make those sections more interesting would detract from the water, so I'd be stuck with a large area of blue sky without any interest. In the next study I move the horizon up toward the top of the painting. This allows me to add more water. I decide to eliminate the foreground rocks so I can focus on the water. The rocks sloping down into the sea on the left form a strong diagonal statement, so I make the water form an upward diagonal to cancel the downward slope of the rocks and lead the eye toward the distant rocks out in the water. This will give the painting a feeling of movement.

## 2. EXPERIMENT WITH COLORS

With the compositional problems solved, you can move on to the color pools. I place all the blues I have on a sheet from a canvas pad and dilute them with white to see the colors I have available. I know that Cerulean Blue, Cobalt Turquoise and Grumbacher Thalo Blue are too warm for the mood I want to set for this painting. I know from experience that Cobalt Blue has a low tinting strength, so I rule it out too. Since the predominant color in the painting is blue, I'll use the three remaining blues, French Ultramarine, Prussian Blue and Indigo. While Indigo is technically a blue pigment, Winsor & Newton Indigo is closer to a black with a slight blue tint. I often use it in place of black in my paintings. Now that I've selected the blues required for my painting, I have to pick the reds and yellows. I start with a color pool using Alizarin Crimson and Cadmium Yellow. I like the colors I get with the Cadmium Yellow, but find the

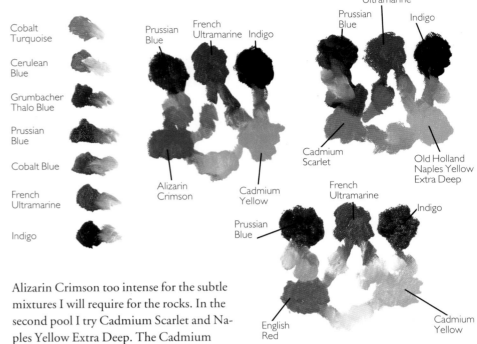

Alizarin Crimson too intense for the subtle mixtures I will require for the rocks. In the second pool I try Cadmium Scarlet and Naples Yellow Extra Deep. The Cadmium Scarlet is also too chromatic, and I still like the Cadmium Yellow better than the Naples Yellow Extra Deep. In the last pool I use English Red, which is a low-chroma red, and Cadmium Yellow. I decide to use the colors in the third pool for my painting.

## 3. TEST THE GROUND COLOR

I often tone my canvas with Permanent Rose, Raw Sienna or Burnt Sienna. I'm not sure which color will work for this painting, so I paint all three on a piece of canvas. When dry, I paint the colors for the sky and water over them to see how they will be influenced by the toned ground. I decide to use the Burnt Sienna ground. Once you become more familiar with the effects created by different grounds you can probably eliminate this step, but it's a good idea to repeat it every so often, especially if you have added new colors to your palette.

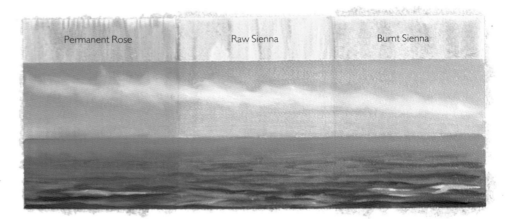

## 4. BLOCK IN THE DRAWING

Now that you've solved the problems of composition and color, you're ready to start painting. Since there isn't a lot of detail, sketch the outline from the drawing onto the canvas freehand with a carbon pencil. Keep the drawing very light so it can be corrected easily. Go over it with French Ultramarine acrylic paint and block in the shapes.

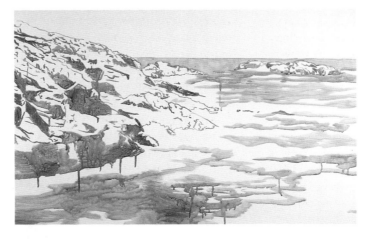

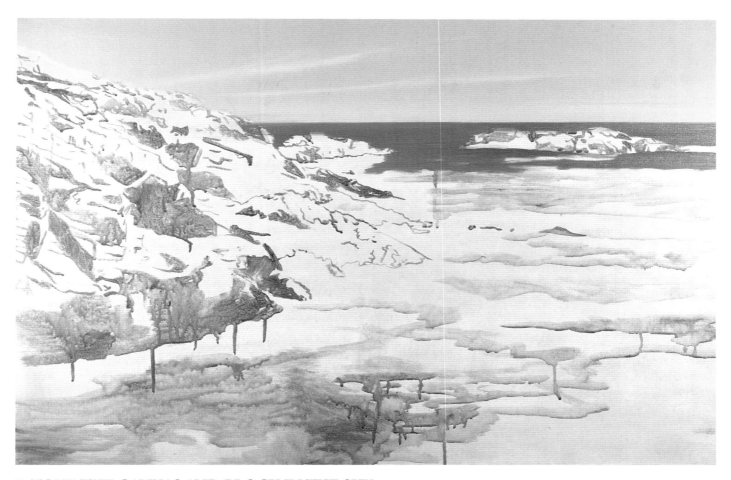

## 5. TONE THE CANVAS AND BLOCK IN THE SKY

Tone the canvas with Burnt Sienna acrylic using a 2-inch (5.1cm) housepainter's brush. (You could also use a mixture of Burnt Sienna oil, Liquin and mineral spirits.) While the tone is drying, mix the colors for the sky and water. The sky color is mixed with French Ultramarine, Prussian Blue and Titanium White. For the distant water, make a deeper version of the sky color by adding Prussian Blue. The clouds will be Titanium White, reduced in intensity slightly with the addition of English Red and French Ultramarine and warmed with a very small amount of Cadmium Yellow. As only the bottom of the sky is showing in this painting, you won't get the gradation of tones seen in a complete sky. Paint the sky a flat tone, adding just a small amount of the cloud color at the horizon to lighten it. Soften the sky with a no. 3 goat-hair watercolor mop brush, dusting it lightly over the sky to remove and blend paint until the paint is smooth and the ground is starting to show through. Then use a dry no. 4 bristle filbert to lift out some of the sky color, exposing the ground where you want to paint the clouds. Use the cloud color you mixed to paint the clouds, using less paint on the bottom of the clouds to give the effect of shadow when they are softened. When you are satisfied with the placement, soften the clouds with a *clean* no. 3 goat-hair watercolor brush. Now, using a mahlstick and a no. 2 watercolor round brush, paint the horizon line. Always make sure your horizon line is level. Just a slight slope up or down will become evident when the picture is finished, and by that time it is too late to correct it. As the horizon is in the distance, you don't want a hard edge where it meets the sky, so tap a no. 6 sable bright along the edge where the sky meets the water to blend the edge. Wipe the brush dry and then draw it along the blend, using your mahlstick as a guide. The edge shouldn't look fuzzy, only soft. Wait for this to dry before moving on to the next step.

### It's Up to You

Since the tone color is transparent, you can sketch and block in the drawing before or after toning the canvas. I've done it both ways in previous demonstrations. I sometimes find a toned ground distracting when transferring the drawing, especially if it is a strong color like Permanent Rose or Cadmium Yellow; with these colors it may be better to add the toning color after the drawing has been blocked in.

## 6. BLOCK IN THE WATER

Mix up all the colors you think you'll need for the water so you won't have to stop painting once you start. Mix a middle and light blue, and then mix straight Prussian Blue with Liquin for the darks. Keep the paint thin; you don't want to build up ridges of paint you'll have trouble covering later. Using a no. 8 bristle flat, start to block in the water. In this painting the strongest contrasts will be in the foreground. As the water recedes, the waves will become smaller and closer together. At this point just mass in the large forms of the water and capture the feeling of movement. Ignore the small details. What you are doing is establishing the structure of the water. Where the sun shines through the water, add Cadmium Yellow for the green glow. Leave the areas of foam and spray open as you will paint them when this stage is dry.

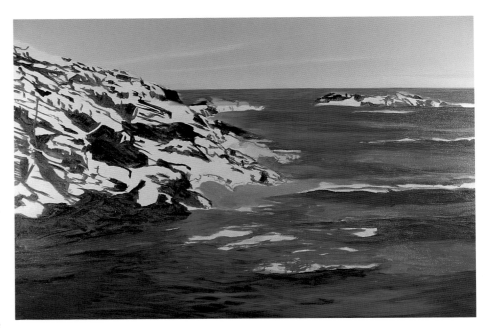

## 7. PAINT THE ROCKS

Paint the rocks with a mixture of French Ultramarine, English Red, Cadmium Yellow, Titanium White and Liquin, using a no. 8 bristle flat brush. When you've finished the rocks, mix English Red, French Ultramarine and Titanium White to make a medium gray. Use this color to underpaint the areas where spray, foam and whitecaps will be added later. Keep the values in the lower ranges at this stage as you want to be able to work from dark to light.

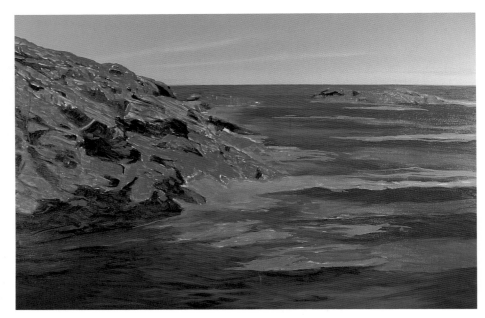

## *Tips for Painting Water*

- Keep in mind that water can be either transparent or reflective, depending on the direction of the light.
- Moving water is sculptural—it has form.
- When painting water, keep in mind the rules of perspective, both linear and atmospheric: As things recede they get smaller and the colors become less intense.
- A flat brush is best for painting water—it allows you to "carve" the forms of the waves.
- You should *never* copy water or skies from a photograph, as they end up looking static and lacking life. Both skies and water are full of movement and you must capture this feeling in your painting to make them believable.

## 8. DETAIL THE WATER

Mix the colors for the water, lightening the values and making them less fluid. Since this paint is of a stiffer consistency, first apply a very thin coat of Liquin to the canvas to act as a lubricant, easing application and also speeding drying time. Using Titanium White and the colors you just mixed for the water, start to paint the whitecaps and add details to the water. Keep the value of the white reduced as this will later serve as an underpainting for the impasto highlights. Next, develop the rock forms by blocking in the areas of light and dark.

## 9. DETAIL THE ROCKS

Mix various browns and grays using Indigo, English Red, French Ultramarine, Cadmium Yellow and Titanium White. Keep the colors in the middle values and low-chroma range. Start painting the rocks out in the water and those in the background first. Darken the sides and add details to the distant rocks. Paint the highlights using a small watercolor brush. Work toward the foreground, increasing the range of value and detail. Before starting the details on the foreground rocks, add texture by painting over the foreground rocks using a transparent glaze of French Ultramarine and Indigo mixed with Liquin and mineral spirits, then blot the glaze with a crumpled paper towel.

## 10. CONTINUE DETAILING THE ROCKS

Now you can complete the block-in of the rocks using slightly lighter and warmer colors than used previously. If the values seem too light later, they can be reduced with a glaze once the water is nearer completion. You don't want the large areas of shadow to look like holes in the painting, so add some details in the shadows with a mixture of Titanium White and French Ultramarine. When dry, glaze over the shadow areas with mixtures of French Ultramarine and Indigo to give the effect of depth.

## 11. TEXTURE THE ROCKS

Using a transparent glaze of Indigo and French Ultramarine and an old, worn brush, add a broken glaze to the rocks, not covering the previous painting except in the shadow areas. This will give more texture to the rock. You can also add texture by spattering, a technique traditionally used with acrylic or watercolor paints. Mix a glaze of French Ultramarine, Indigo and Liquin and thin it with a small amount of mineral spirits. Cover all the areas of the canvas you don't want the spatter to reach with newspaper, taping it in place with masking tape. Using a stencil brush or other stiff-bristled brush, flick the brush hairs with your index finger, sending a spray of paint over the rocks. *Always* wear a rubber glove when spattering to avoid contact with the Liquin and mineral spirits. In addition, the paint will get under your fingernails and will be hard to remove. When you finish spattering, use a small sable flat to soften or remove the larger spatters in the background rocks. Follow the rules of perspective: The size of the spatter should decrease as it moves backward in the painting. Using a glaze of French Ultramarine and Cadmium Yellow, stipple it over the rocks at the waterline to indicate moss. Use mixtures of English Red, French Ultramarine, Indigo, Cadmium Yellow and Titanium White to make minor refinements to the shapes and planes of the rocks. Allow the painting to dry completely before the next step.

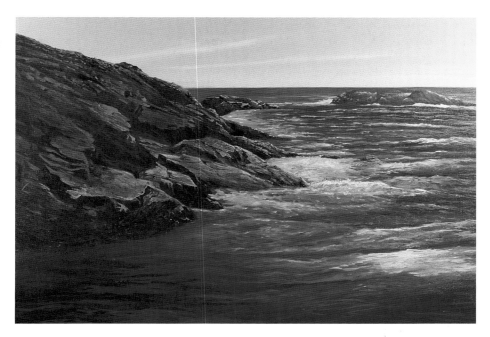

## Painting Rocks

When painting rocks I use glazes, spattering and blotting to produce realistic effects. The texture and patterns formed by rocks are created by nature, and are therefore abstract and random. Using the above techniques and your imagination, you can paint rocks that are far more realistic than if you had copied them from a photograph.

## Masking Tip

Masking tape can sometimes lift paint when removed. To weaken the adhesive and prevent it from pulling up paint, apply the tape to your clothing and remove it a couple of times. This trick can also be used to mask watercolor or acrylic paintings to prevent damage to the surface of the paper.

## 12. REFINE THE WATER AND ROCKS

Premix all the colors you've used in the water in previous steps so you can repaint and adjust areas. The advantage in working with a limited palette is that it is easy to match colors. Remember, the more colors you use in a painting, the greater the problems of both matching and achieving a unity of color. Mix a slightly brighter white than the one used in the earlier stages, but don't use pure white yet. You can also mix transparent glazes of French Ultramarine, Prussian Blue and Indigo to deepen areas that are too light, then paint detail into the wet glazes. Start at the top of the water and work toward the foreground. The bottoms of the rocks in the distance are flat too, so repaint the waterline to make it look as if they are overlapping. Mix some Indigo and English Red and thin it with Liquin to add more cracks in the foreground rocks. Use a crumpled paper towel dipped in paint to add more texture to the rocks. Work on the middle section of the painting, mixing various shades of blue, gray and green to adjust the waves painted earlier. For this stage use a no. 2 watercolor round so you can add fine

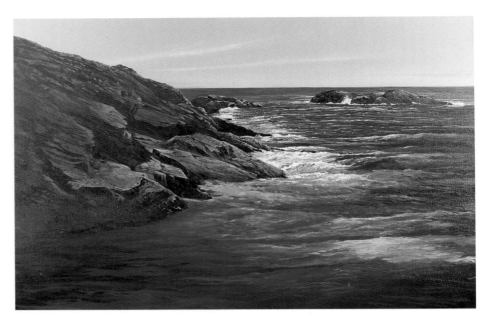

details. Apply impasto paint for the highlights on the water. Paint a glaze of English Red, Cadmium Yellow and Titanium White over the rocks at the top of the painting to warm them and also to reduce their value slightly. Use very little white as you don't want to make the rocks appear to be in a fog, just increase their value slightly.

## *Sketch Details With Pastel*

When faced with the problem of adding detail to a painting, I often draw the shape lightly on the painting with white pastel. The pastel can be easily removed, yet gives an outline to follow. Pastels mix into the paint, disappearing as you work. When the paint is dry, you can remove any remaining pastel by wiping the area with a damp sponge or rag. You can also use a variation of this method when working from a detailed drawing. The drawing can be transferred to the canvas by rubbing the back with pastel and then tracing over the lines with a pencil or stylus. If you are working on stretched canvas, you must place a book or solid object behind the canvas to prevent the canvas from stretching and to keep the pencil from piercing the canvas. This method is very helpful when painting technical or architectural subjects with complex detail. It also allows you to transfer just the information you need for each painting session.

## 13. SKETCH IN THE SPRAY SHAPES

Your next step will be to paint the spray hitting the rocks. You don't want the spray to be too large or symmetrical. Use a white pastel to sketch in the shape of the spray.

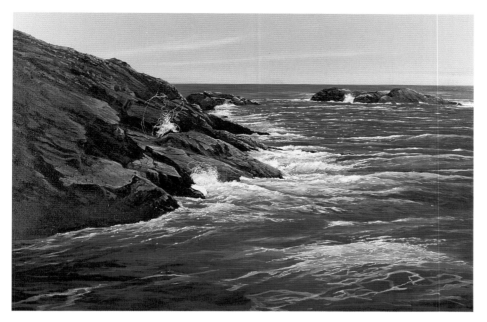

## 14. START THE FOAM AND SPRAY

The paint should now be applied impasto so it catches the light. To give the effect of the froth where the sea is meeting the rocks, gently tap the paint with your index finger, blurring the edge. Start to paint the spray washing over the rocks; this must be done in several stages as you want the paint to build up so it will catch the light. Paint the area where the pool of froth will be, softening the edges. Water produces abstract forms; to make it believable you must keep this in mind while you are painting it. If it is too structured, it won't look like water.

### *Keep Paint Handy When Working Small Areas*

When working on a small area of a large painting, I find it's inconvenient to have to keep going back to the palette for more paint and, since I'm usually using a mahlstick, I can't use a handheld palette. I solve the problem by placing a small amount of the paint I'm using on a piece of masking tape, then sticking it to the painting adjacent to the area I'm working on. This way I don't have to move my hand or mahlstick to pick up color.

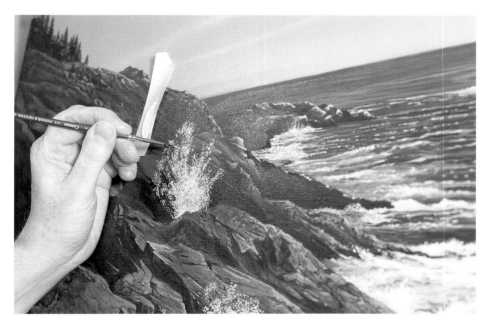

## 15. PAINT THE TREES AND CONTINUE THE SPRAY

Mix a variety of greens using Indigo, French Ultramarine, Prussian Blue and Cadmium Yellow. Unless you want the vivid quality created by Winsor Green or Cadmium Green, it's better to mix greens on your palette. Paint the pine trees at the top of the rocks. They give a sense of depth and scale to the painting and act as a compositional device, breaking the line of the sky and stopping the viewer's eye from leaving the painting. When the paint starts to dry, add the highlights to the trees, making sure the values are reduced so they won't jump out of the picture. Next, glaze Prussian Blue mixed with Liquin over the foreground water; when the underpainting shines through, it will produce a blue that is far more luminous than could be achieved by mixing the colors on the palette. Due to the high concentration of Liquin, this glaze will start to get tacky quickly. Take advantage of this by painting the lights and water spray into the glaze using a no. 6 acrylic flat. Paint a glaze of Liquin and a very small amount of French Ultramarine over the spray you painted in the previous step—be sure the spray is totally dry first or the glaze will dissolve the paint. Remember that impasto paint, even when mixed with Liquin, will take longer to dry. When the French Ultramarine glaze sets—it doesn't have to be totally dry—paint more droplets of spray using impasto white paint, slightly lowered in value. Use a no. 0 watercolor round brush to apply each droplet. Allow parts of the spray you glazed with French Ultramarine to show through this application to create depth.

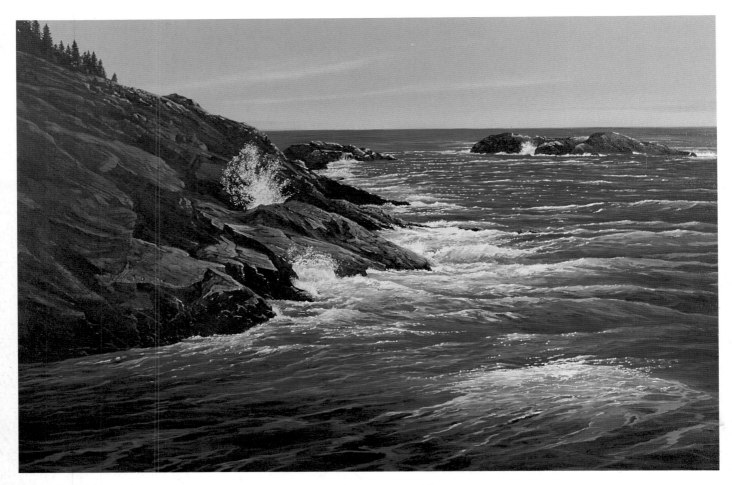

## 16. FINISH THE ROCKS AND START WATER SPARKLES

When completed, this painting will consist of a full range of values, from Indigo (which is equal to black) to the full-strength Titanium White reserved for the sparkle on the foam and water. This is one of the few times you'll use pure Titanium White without reducing its value. Mix the local colors for the rocks and use a no. 0 watercolor round to add details to the rocks and indicate some detail where they meet the water. If the rocks look too light you can always adjust their value with a glaze later. Using Indigo thinned with Liquin, add final details to the rocks. Using white that is slightly reduced in value, start to add small dots of paint in the middle ground and foreground of the painting to give the effect of sparkle on the water. Except for the addition of the highlights and some final adjustments, the painting is almost finished. Allow the painting to dry for a couple of days before adding the finishing touches. The night before you plan to finish the painting, mix some pure Titanium White on your palette and allow it to stiffen overnight.

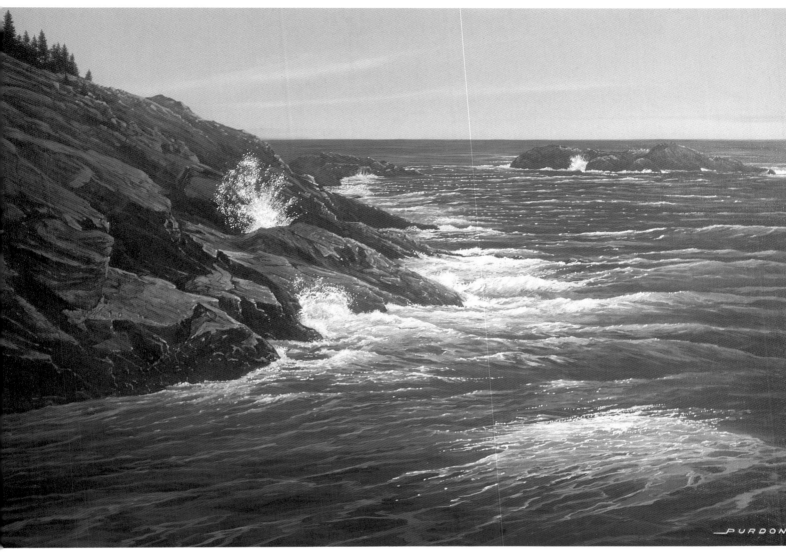

## 17. FINE-TUNING

Put the painting back on the easel and take a long, hard, critical look at it to see where adjustments can be made. These adjustments will be made using impasto paint that will catch the light. Up until now you have not used pure white—now is the time to use the white you allowed to stiffen overnight to add the final sparkle to the water and spray so they will come forward in the painting. The rocks in the background need to be lessened in value slightly; this can be accomplished with a milky glaze of Titanium White, English Red and French Ultramarine. This must be done carefully; if you lighten the rocks too much, you will upset the balance of values in the painting. At the same time, glaze the highlights of the rocks in the background with a glaze of Indigo and English Red to reduce their value slightly. Once these minor adjustments are made the painting is finished. Now sign it and allow it to dry before varnishing and sending it to the framer.

# 5 *Fixing Problem Areas*

In the previous chapters I have shown how you can solve potential problems before beginning to paint. Even with the best planning, when you finish a painting you will probably have to make a few adjustments. Hopefully these will be minor and you'll be able to correct them easily. But even the most experienced artist doesn't get it right every time! This chapter will show how to critique your painting to find these problems and how to correct them.

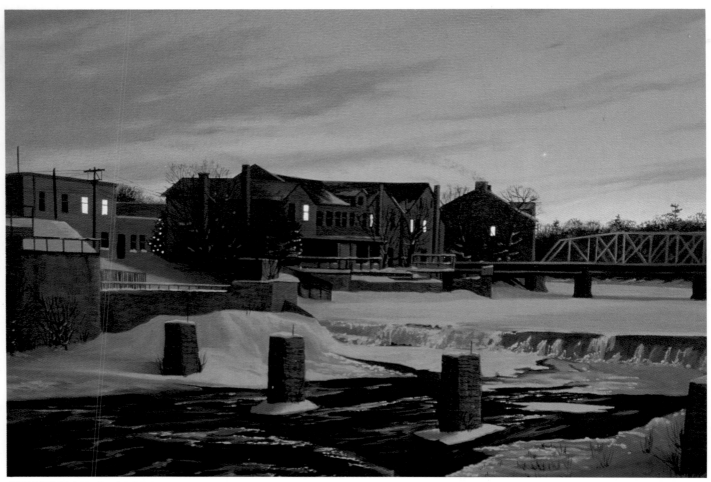

CHRISTMAS EVE—ELORA
*alkyd and oil on canvas, 12" × 16" (30.5cm × 40.6cm)*
*Private collection*

## KNOW WHEN TO START OVER

Luckily, oil paint is a forgiving medium. Value, color and small drawing mistakes can be corrected by using glazes or by repainting small areas. Errors in basic composition, drawing and color are harder to correct. If you've planned your painting, hopefully you will have noticed these problems before starting and corrected them. However, even with the best planning, sometimes you will realize when you finish a painting that it has a major flaw.

If the error is one of composition, sometimes you can cut the painting down to a new size and restretch it on smaller stretchers in a different format. Watercolor painters often find that when they finish a painting one part is better than the rest, and they will cut the painting down to a new format and size. While this is more difficult when working with stretched canvas, it is an option to consider before discarding a painting.

Unfortunately, some problems with the basic composition or drawing can't be fixed and the only option is to scrap the painting and start over again. Your reputation as an artist rests on the consistent quality of the work you produce. While it is heartbreaking to scrap a painting, it's far better to start over than to have a poor painting become representative of your work. If the painting is a total loss, rip it up. You don't want it to return to haunt you one day! A friend of mine threw one of her student works in the garbage. When she was walking home one evening, she happened to glance into a large house and there, hanging above the mantel in an elaborate frame, was the painting she had consigned to the trash bin! If you are using a stretched canvas, it costs very little to remove the canvas and restretch a fresh piece on the old stretchers.

## Critique Checklist

Here is a checklist of questions you can use to critique your painting.

### COMPOSITION

- Where is the focal point? Does it add or detract from the work?
- Is there a clear point of interest? If there are multiple points of interest, is one dominant? (There should be one dominant focal point.)
- Where does your eye enter and leave the painting?
- Does something lead your eye out of the painting before you have seen the focal point? (Your eye should travel around inside the painting, not be drawn out.)
- Is the painting in balance? Does one side seem heavier than the other?
- Turn the painting upside down and on its side. Does it work as an abstract piece of design?

### DRAWING

- Is the horizon line level?
- Is the perspective correct?
- Are light and wind directions consistent throughout the painting?
- Are there any hard edges in the background? (Hard edges should only appear in the foreground due to atmospheric perspective.)
- Does the foreground contain more detail than the middle ground and background? (The foreground should be the most detailed area, with the detail fading as you move toward the background.)
- A good rule to follow is "If something looks wrong, it usually is!"

### VALUE

- Does the painting have a sense of depth? (Cover one eye to see if the painting looks three-dimensional.)
- Do the values follow the rules of atmospheric perspective? (The full range of values should only be seen in the foreground. The values in the middle and background should be closer in range, and shouldn't include the darkest darks and lightest lights.)
- Are the values consistent throughout the painting? (The values in each plane—middle ground, background—should be consistent. Also, if the painting is a low-key or high-key painting, all the values should stay within that range.)

### COLOR

- Do the colors create proper depth? (Colors should be warmer in the foreground and cooler in the background as warm colors advance and cool colors recede. Colors in the foreground should also be higher in chroma than those in the background due to atmospheric perspective.)
- Is there one pure color? (There should be only one pure color in any painting; the others should all be slightly reduced in intensity.)
- Are all objects darker in the shadows than in the light? (Colors should never be brighter in the shadows than in the light.)

### AMBIANCE

- Do the colors and lines you've chosen convey the emotion or mood you intended the painting to express?

Remember that color has a psychological effect on the viewer. Here are some possible interpretations for various colors:
- black, white, gray—cold, unfriendly
- red, orange, yellow—exciting, warm, cheerful, pulsing
- green—serene, peaceful, vital
- blue, violet—mysterious, cold, soothing, calm

Line also has a psychological effect on the viewer. Following are some qualities various lines could suggest:
sharp angles and jagged lines—excitement, tension, shock, suspense
curved lines, circles and ovals—serenity, grace, femininity, motion

# Carousel Chargers

## *Materials Used in Finished Painting*

### OIL PAINTS
- Permanent Rose
- Alizarin Crimson
- Cadmium Red
- Cadmium Yellow
- Winsor Blue
- Indigo
- Titanium White
- Zinc White

### ALKYD PAINTS (Optional)
- London Red
- London Yellow
- French Ultramarine
- Dioxazine Purple

### BRUSHES
- no. 8 bristle filbert
- no. 0 watercolor round
- no. 2 watercolor round
- ¼-inch (0.6cm) sable bright
- no. 3 Winsor & Newton series 240 goat-hair watercolor brush or badger fan blender

### OTHER
- 12" × 16" (30.5cm × 40.6cm) stretched canvas
- carbon or charcoal pencil
- Liquin
- X-Acto knife with a rounded blade, or craft knife

## 1. CRITIQUE YOUR PAINTING

The painting at right is based on some photographs and sketches I did at a fall fair a few years ago. I began with a light orange ground of London Red and London Yellow alkyd, then used oils for the rest of the painting. The color pool for this painting was only five colors and Titanium White. The painting is close to being finished, but there are errors in composition, value and color that will now have to be corrected. Using the checklist on page 111, these are the problems I have found:

### *Composition*

The small horse on the far left of the painting is too close to the edge; when the painting is framed it will touch the frame. You lose at least ¼-inch (0.6cm) at the edge of your painting due to the overlap of the frame.

### *Drawing*

The grid pattern in the background at the right isn't symmetrical and is badly drawn. The mechanical parts at the top aren't straight and corners are rounded, not square.

### *Color*

The red areas on the gray horse are too close in both chroma and value to the red areas on the yellow horse. These areas will have to be adjusted to make the yellow horse advance and the gray one recede.

### *Value*

The values in the foreground are not consistent: The two horses are close in value, yet the gray horse is in shadow. The gray horse will need to be darkened and the yellow horse lightened. The light gray of the canopy at the top of the carousel is close in value to the blue of the sky and tends to blend with it when viewed from a distance.

### *Ambiance*

I like the cheerful effect the painting has, but feel that it will be even more effective when the colors have been intensified by reducing values and with the use of complementary colors in the shadows.

Now that the problems have been noted, we will now start to correct them.

### *Critique Your Painting With a Fresh Eye*

When I started teaching I was surprised how easily I could critique students' work and notice drawing mistakes. It is far easier to find problems in someone else's work than in your own. When you work on a painting, you develop "tunnel vision" and don't notice errors you would readily notice in someone else's work. That's why I suggest when you finish a painting you place it in storage and resist the temptation to look at it for a few days. When you take it out of storage, place the painting on your easel and stand back from it at a proper viewing distance—now you will see it with a fresh eye. I do this with all of my paintings.

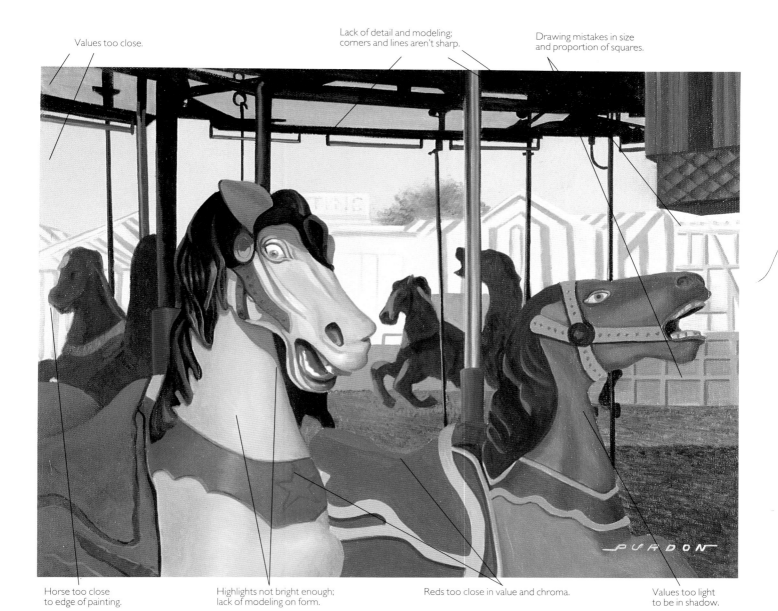

Values too close.

Lack of detail and modeling; corners and lines aren't sharp.

Drawing mistakes in size and proportion of squares.

Horse too close to edge of painting.

Highlights not bright enough; lack of modeling on form.

Reds too close in value and chroma.

Values too light to be in shadow.

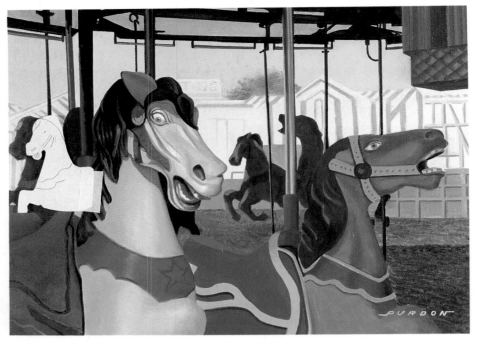

## 2. USE A CUTOUT SHAPE TO FIND A BETTER COMPOSITION

The composition problem is the most difficult to correct. The only way to solve it is to move the horse to the right so it doesn't touch the frame, or enough to the left so the frame will cut it at a suitable point. I make a drawing of the horse on a piece of paper, cut it out, and use masking tape to stick it onto the painting and move it to different positions to see where it will look best. When you want to make a change to a painting or add something, this is a good way of seeing how it will look before you start to paint. I often use this method to place birds in a seascape so I can see the patterns they make before painting.

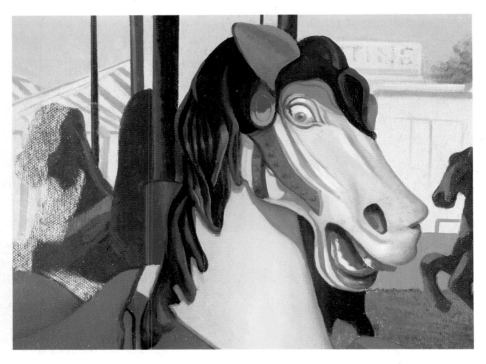

## 3. SCRAPE OFF THE OLD PAINT

I find that by moving the horse slightly to the right I will have enough open space in front to solve the problem. If I paint over the existing horse with a lighter color, I risk that it will start to show through in a few years. To avoid this, I use a sharp knife to scrape as much of the paint off as I can, being careful not to cut the canvas or remove the gesso ground. I find that an X-Acto knife with a curved blade is the best knife for this purpose—since the rounded blade doesn't have a sharp point, it is less likely you will cut the canvas. It's only necessary to remove the paint where I will be repainting with a lighter color.

### Don't Repaint Large Areas

You cannot repaint large areas, as you lose the effects of the toned ground and also risk that the previous work will show through with the passage of time. This effect is called *pentimento* and can be seen in some of the paintings of the Old Masters. In some of Canaletto's paintings the figures that were painted on top of the finished background have turned into transparent "ghosts"—you can see through them.

## 4. REPAINT THE OBJECT IN THE NEW POSITION

I repaint the horse in the new position and fill in the striped tent in the background. I notice that the larger area of light value created when the horse is moved is a distraction, so I place a dark fence in front of the horse to act as a visual stop, keeping the viewer's eye from being drawn out of the painting.

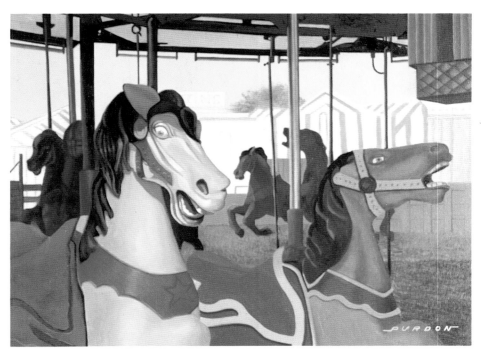

## 5. REPAINT DRAWING ERRORS

The most noticeable drawing error is the pattern of squares in the right background—they are crooked and unbalanced. If the rest of the painting was done in a sketchy manner this wouldn't matter as much, but if you paint realistically, you must be consistent throughout the painting. As I am not painting a lighter color over a dark color, I don't have to worry about the underpainting bleeding through, so I won't have to scrape the paint first. When I repaint, I reduce the intensity of the color slightly so this area will recede. I find the two different patterns of squares distracting, so I overpaint the one at the top and add some stripes so it will blend in with the rest of the background. I keep this area keyed down so it won't clash with the foreground or lead the eye toward the edge of the painting. The angles and edges of the equipment at the top of the painting have to be corrected and some details added to develop form, but again the values are kept reduced so this area won't compete with the center of interest. Mixing Titanium White with Dioxazine Purple, I add detail to the neon tubes. The horses in the central background look unfinished, so I correct the drawing and add some minor details.

115

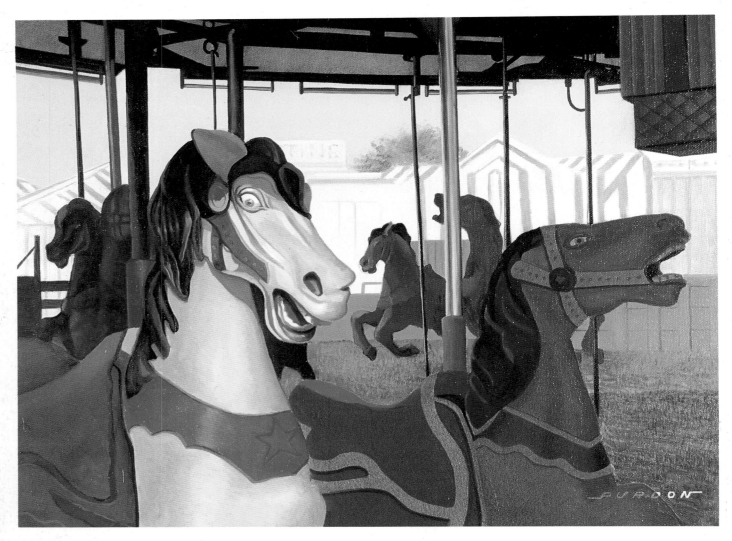

## 6. CORRECT VALUES WITH GLAZES

The yellow horse is supposed to be the focal point of the painting, yet I feel that the gray horse is too prominent and the painting lacks a dominant center of interest. To correct this I will adjust the values of the gray horse using a glaze. A glaze will adjust both the colors and values without having to repaint the area. I use alkyds for glazing because of their drying speed and also because of the brilliance they give to the colors. (You could also use oils.) I make a glaze of Dioxazine Purple and French Ultramarine mixed with Liquin and paint it heavily over the area I want to darken. Then, using a blending brush, I remove the glaze until I achieve the value I want. As the glaze cannot be removed when dry, you must be sure the value is correct while it's still wet. If in doubt, it's better to keep it lighter; you can always darken it with another glaze when dry. If the area becomes too dark, the only way to correct it is to repaint it completely. I am using a blue/purple glaze as it is the complementary color of yellow—this will intensify the yellow horse. I glaze the top of the carousel with French Ultramarine, London Red and London Yellow. I glaze London Red and French Ultramarine to adjust the modeling of the saddle of the yellow horse as it looks too flat.

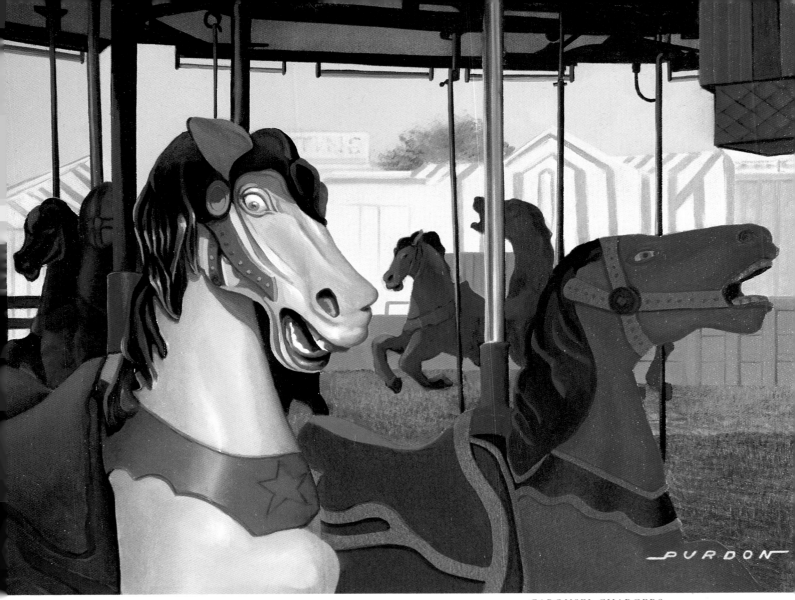

## 7. BRIGHTEN THE COLORS AND ADD HIGHLIGHTS

CAROUSEL CHARGERS
*12" × 16" (30.5cm × 40.6cm)*

Besides adjusting the value, the glazes have also changed the color. The red areas on the gray horse are now reduced in chroma and move into the background. All the large areas of color have been corrected in chroma and value. The yellow horse looks flat, so I adjust the modeling using glazes and add highlights with opaque paint. I use a glaze of Alizarin Crimson and Dioxazine Purple to darken the edges and make the form turn. I add the highlights with Titanium White and Cadmium Yellow. I soften the edges of the highlights with a softening brush. Mixing a gray from Indigo and Titanium White, I add details and highlights to the

yellow horse's mane. I use a semiopaque glaze of Winsor Blue and Zinc White to give the effect of light catching the saddle and the top of the yellow horse's head. I paint a thin line of Permanent Rose and Titanium White along the bottom edge of the neon tubes, giving the effect of light catching them. I now repaint my signature and the painting is finished. If you compare the finished painting with the one in step 1 you will see what I mean by "fine-tuning." This process of self-critiquing and correcting your work makes the difference between a good painting and an excellent one.

117

# 6 Gallery of Paintings

In the previous chapters I have shown you how I complete a painting using step-by-step demonstrations. These were done for this book to show you my working methods. Now I would like to share more of my work with you. In this section are paintings done over many years, including my very first painting. (I won't tell you when it was painted, but if you have sharp eyes, you might be able to see the date.) The most recent painting was done just before I finished this book. I hope you will enjoy looking at them, and now that you know "the secrets," will appreciate these paintings even more. Welcome to my gallery!

OSLER BLUFF—COLLINGWOOD, ONTARIO
*oil on canvas board, 18" × 24" (45.7cm × 61cm)*
*Collection of the artist*

This was the first oil painting I ever did. It has many faults, but it was the beginning of my painting career. I had no knowledge of the materials I needed, so the clerk in the art store helped me choose my colors and brushes. When the bill was added up it was over my budget, so I returned some of the colors I didn't think I would need, along with the artist's linseed oil, as I knew I had a can of linseed oil from the hardware store at home. That was mistake number one—as you can see, the commercial linseed oil has yellowed over the years. Full of confidence, I entered the finished painting in a local art exhibition and (believe it or not) received the second prize: a small oil sketching set and a pocket book by Henry Gasser entitled *How to Draw and Paint*, which I still have. The first thing I learned from Mr. Gasser was *not* to use linseed oil from the hardware store!

It was a hot summer day when I sketched this scene in the Margaree valley, so I used warm colors for the painting. When I started to work on the painting in the studio, I did a detailed pencil drawing, working from photographs I had taken on location. I removed some houses and buildings and added others. When I was pleased with the composition, I transferred the drawing to the canvas and then reinforced it with Ultramarine Blue paint. I toned the canvas with a light stain of Cadmium Yellow. I completed the sky, except for the lights on the clouds, while it was still wet. I then painted the picture from the background to the foreground. In the background the values were reduced slightly from the right to left of the painting to show that the valley moved away.

MARGAREE—NOVA SCOTIA, CANADA
*oil on canvas, 16" × 20" (40.6cm × 50.8cm)*
*Collection of Mr. Garrett Herman, Toronto*

While driving home from visiting friends at Christmas time, I took a road I hadn't used before and came upon this scene. The sun had set, but there was still a glow in the sky, and the bare trees were silhouetted against it. I did a small pencil sketch, noting the colors. I started work on the painting the next day while the scene was still fresh in my mind, working on a canvas toned with a thin stain of Cadmium Yellow. And to answer the question I am always asked about this painting, yes I did paint *every* branch. I completed the painting using only four colors in addition to Titanium White: Permanent Rose, Cadmium Yellow, Ultramarine Blue and Indigo.

WINTER LIGHT
*oil on canvas, 18″ × 24″ (45.7cm × 61cm)*
*Private collection*

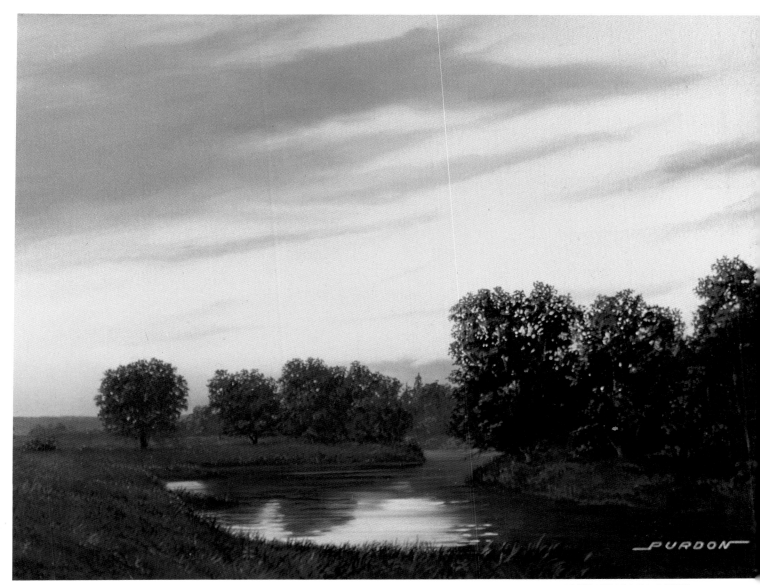

I painted this scene using only four colors, plus white: Permanent Rose alkyd, Dioxazine Purple alkyd, Cadmium Yellow alkyd and Indigo oil. Indigo isn't available in alkyds so I used oil, and only used this color in the darks. I used alkyds where I wanted the effect of light. I mixed a small amount of Flake White with the Titanium to increase its transparency and reflective qualities. I underpainted the details in the dark areas using mixtures of purple, rose and white. When it was dry, I applied glazes of purple and rose, deepening the values but allowing the light to reflect from the underpainting. Alkyds not only speed up the working process, but add a luminosity that can't be achieved with oil paint. Again, the paint was applied heavier in the light areas and thinner in the shadows.

EVENING—NOTTAWASAGA RIVER
*alkyd on canvas, 12" × 16" (30.5cm × 40.6cm)*
*Collection of Mr. & Mrs. Kevin Moloney, Canada*

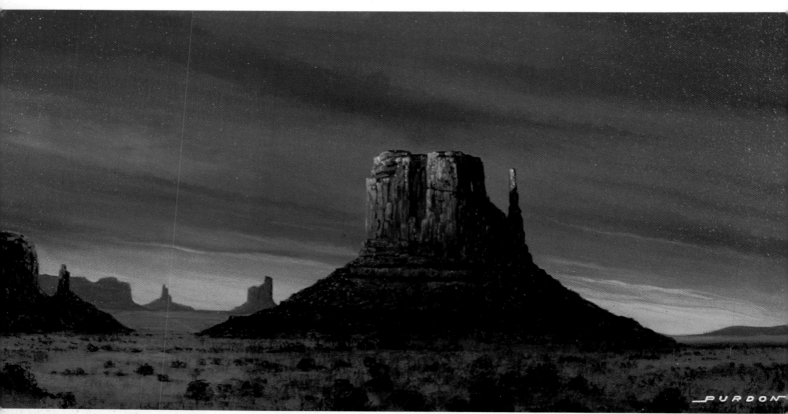

I tried to capture the impact of the setting sun in the desert with this painting of Monument Valley. I toned the canvas with Burnt Sienna and used oil paint for earlier stages of the painting, completing it using transparent alkyd glazes over the dry underpainting. I underpainted the top of the formation being hit by the setting sun with Cadmium Red and Cadmium Yellow oil paint and, when dry, glazed it with Alizarin Crimson and London Red alkyd. The foreground desert was built up using glazes of London Red, Dioxazine Purple and Alizarin Crimson, using an old, splayed brush to apply a broken texture. While this glaze was still wet I used an old round brush and Dioxazine Purple to dab in the sagebrush. This painting is an example of how the effect of light can be achieved without using the higher values. The lightest area is only about value 3.

SUNSET AT THE LEFT MITTEN
*oil and alkyd on canvas, 12" × 24" (30.5cm × 61cm)*
*Collection of the artist*

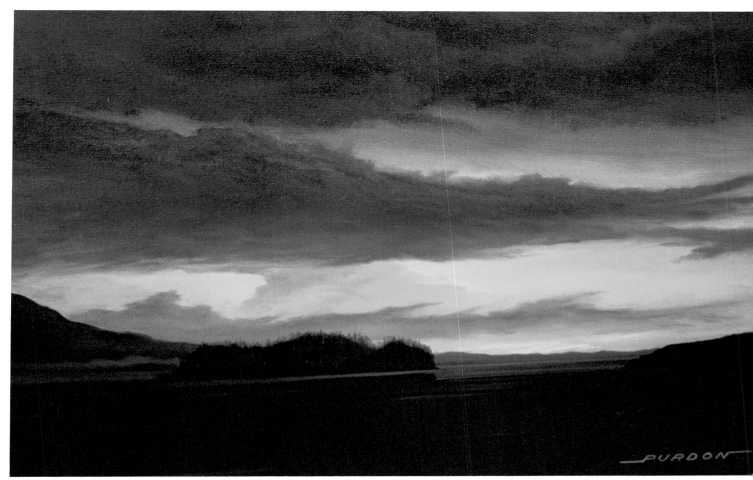

Northern skies are majestic. I did this study, intending to do a larger painting later, on a very cool September evening on a ferry sailing up the coast of British Columbia just south of Prince Rupert. However, when I tried to do the larger painting I realized that what worked well in a small painting became overpowering on a large canvas. I left the partially completed painting around the studio for about a year and kept changing the colors and values, but finally I gave up and destroyed the canvas. Perhaps one day I will try again.

NORTHERN FIRE
*oil on canvas, 12" × 16" (30.5cm × 40.6cm)*
*Private collection*

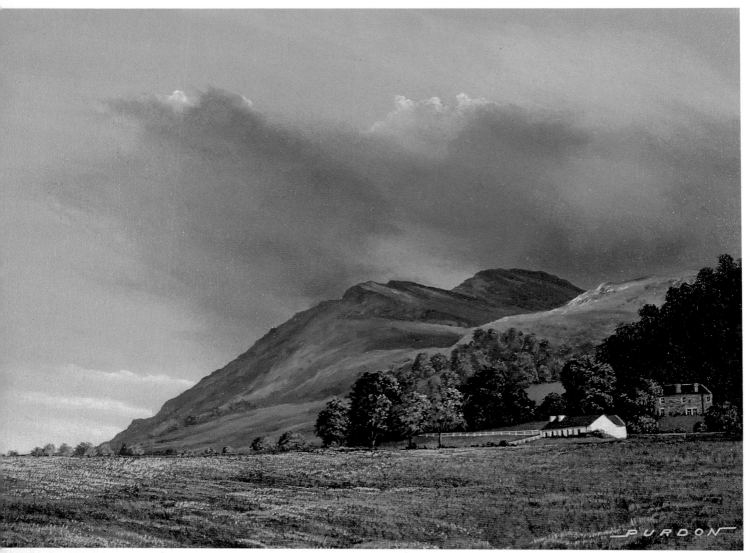

The painting was done mostly from memory, with the help of some small reference sketches. The clouds broke over the hills, and the sun illuminated the stubble on the field and parts of the hills in the early evening. If you don't live in a hilly or mountainous area, you don't see how the shadows of the clouds produce patterns of light and dark on the landscape. These patterns can be used to great effect in a painting to indicate form and break up large areas of color. To create the effect of evening light, I used a thin transparent ground of Raw Sienna. When using Raw Sienna or Burnt Sienna, they must be kept thin or they will become too dark and, instead of creating light, they will kill it. The top of the hill catching the sun was painted using impasto paint. I used pure Naples Yellow (containing lead carbonate) for the yellow highlights in this painting because of its reflective properties. Naples Yellow Hue doesn't contain lead and therefore doesn't produce the same result.

OCHIL HILLS—EVENING
*oil on canvas, 12" × 16" (30.5cm × 40.6cm)*
*Collection of Dr. R. MacKean, Scotland*

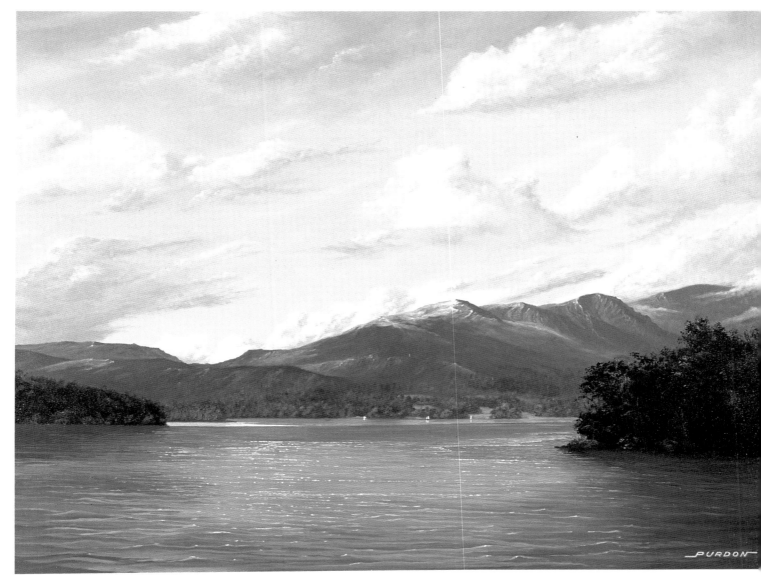

This was a perfect Lakeland morning—a light breeze was blowing, the clouds were moving lazily across the sky and a few sailboats were out catching the morning breeze. I did a small watercolor that I later used as a guide for this painting. I toned the canvas with a thin stain of Cadmium Yellow mixed with a small amount of Cadmium Orange. I painted the sky in one session so that I could make changes. While the sky was still wet, I painted the edges of the hills, softening them slightly so they wouldn't look as if they were cut out of paper. When the sky had dried I completed the background hills and blocked in the foreground and the water. I left the painting to dry and then added the highlights to the sky and water using impasto paint. The breeze had caught part of the water, producing a wind shear that was reflecting the sunlight—to create this light effect I applied the paint with a palette knife. The sailboats were in the distance, so I painted the white triangle of the sails with impasto paint.

LAKE WINDERMERE—ENGLAND
*oil on canvas, 24" × 30" (61cm × 76.2cm)*
*Collection of Mr. & Mrs. G. Usling, Canada*

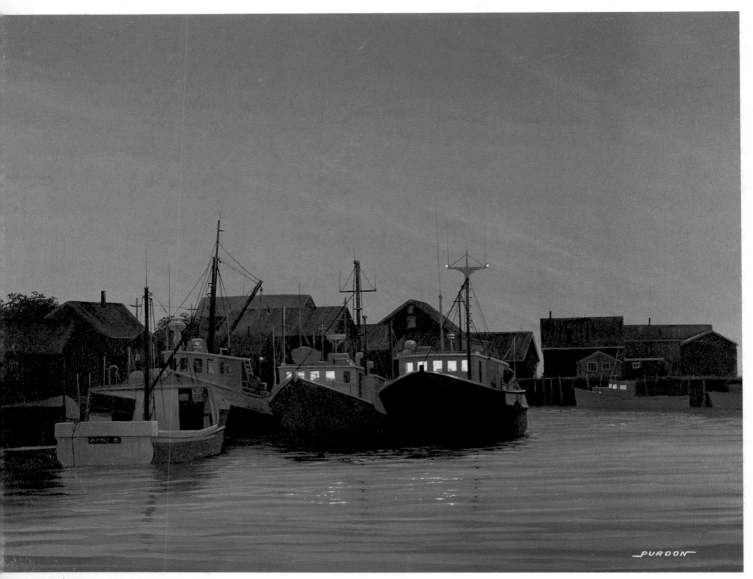

CHÈTICAMP—NOVA SCOTIA, CANADA
*oil on canvas, 22" × 28"  (55.9cm × 71.1cm)*
*Collection of Mr. & Mrs. G. Usling, Canada*

# Conclusion

Now I have to write the most difficult page of this book. When I started writing this book I was told by many that it would quickly become an all-encompassing monster I would rapidly grow to hate. Happily, this hasn't been the case! I have enjoyed every minute and can honestly say I hope that you enjoyed reading it as much as I did writing it.

I have tried to not only explain the methods and materials I use, but to also help you understand how things are done and why. There was a movie a few years ago called *The Paper Chase* in which John Housman says, "I will teach you to think like lawyers." What I have tried to do in this book is to teach you how to think like an artist. I have also tried to give you a sense of the excitement and adventure that each new painting brings.

I have always enjoyed teaching, and with this book I have had the opportunity to teach to my largest audience. Luckily, early on I forgot how many people would be reading this book and imagined myself only talking to you. I hope you come away feeling that you spent some time with me in my studio—and that it was a worthwhile visit.

When you decided to be a painter you set forth on a lifelong voyage of discovery. That voyage will never end: An artist is always looking toward the horizon for new lands to explore. I hope this book was one of those lands you enjoyed visiting along the way and that you will return here often.

Have a long, exciting and happy trip, and never lose the joy and wonder of creation.

# Index

**A**
Acrylic paint, 29
Alkyd paint, 29, 62-75

**B**
Blending, 30
Brilliant colors, 23
Brushes, 11-12
    cleaning, 11, 30
    old, 78

**C**
Cleaning brushes, 11, 30
Colors
    brilliant, 23
    pooling, 24, 28, 36-37, 42, 49, 55, 77, 84
    roots, 25
    transparent, 64
Color study, 28, 36-37, 65, 77
Composition rules, 19
Critique checklist, 111
Cutout shapes, 114

**D**
Details, painting, 43, 51

**E**
Edges, 31, 50, 79
Experience, painting from own, 26

**F**
Fixing problems and mistakes, 31, 110-117

**G**
Glazes, 32-33, 64, 66, 67-68, 71-72, 95-96, 116

**H**
Highlighting, 60, 68, 117

**I**
Impasto, 33, 60

**L**
Lead paint, 16
Liquin, 63
Location, painting on, 83

**M**
Mahlstick, 12
Masking, 105

**O**
Oil paint, 13-16
Old brushes, 78
Old paint, scraping off, 114

**P**
Paintings, 118-126
    *Agathlan, The*, 34
    *Bounty Hunter*, 61
    *Bristol Harbor—Evening*, 76
    *Carousel Chargers*, 117
    *Cheticamp—Nova Scotia, Canada*, 126
    *Christmas Eve—Elora*, 110
    *Daybreak on the Coast*, 20
    *Evening—Nottawasaga River*, 121
    *Kew Cottage*, 90
    *Lake Windermere—England*, 125
    *Land of the Mountain and the Flood*, 47
    *Lazy River Farm*, 62
    *Lobster Cove*, 109
    *Margaree—Nova Scotia, Canada*, 119
    *Northern Fire*, 123
    *Ochil Hills—Evening*, 124
    *October Morning*, 82
    *Old Angus*, 69
    *Osler Bluff—Collingwood, Ontario*, 118
    *Red Rocks Of Sedona*, 53

    *River Torridon And Sgurr Dubh*, 98
    *Sheldaig Island—Evening*, 75
    *Silent Night*, 8
    *Sunset at the Left Mitten*, 122
    *Waiting for Spring*, 40
    *Watchers, The*, 10
    *Winter Light*, 120
Palette, 17
Pooling, 24, 28, 36-37, 42, 49, 55, 77, 84

**R**
Repainting, 114-115
Roots, color, 25

**S**
Shadows, 22, 88
Studio, 18
Supports, 12

**T**
Tonking, 85
Transferring, 38, 56
Transparent colors, 64
Tubes, plugged, 63

**V**
Value
    blocking in, 39
    glazes, correcting with, 116
    lightening, 21-22
    ranges, limited, 22
    shadows, 22

**W**
Washing, 38